W9-CQX-047

The Graphic Art of Tattoo Lettering

B.J. BETTS
NICK SCHONBERGER

Art direction & design
CHRIS LAW

 Thames & Hudson

CONTENTS

THE STYLES

OPPOSITE ▷ LOST ANGEL ~ MISTER CARTOON, P. 109
 AND UNTIL WE MEET... ~ EM SCOTT, P. 172
 FAMILIA... ~ BIG SLEEPS, P. 96
 LIGHT SURROUNDS ME ~ BERT KRAK, P. 61
 DEATH BEFORE DISHONOR ~ STEVE BOLTZ, P. 44

THE GRAPHIC ART OF
TATTOO LETTERING

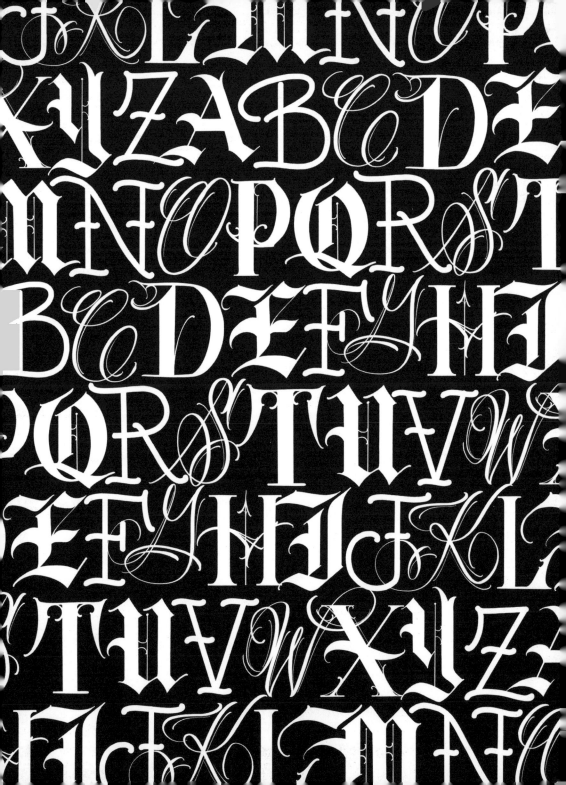

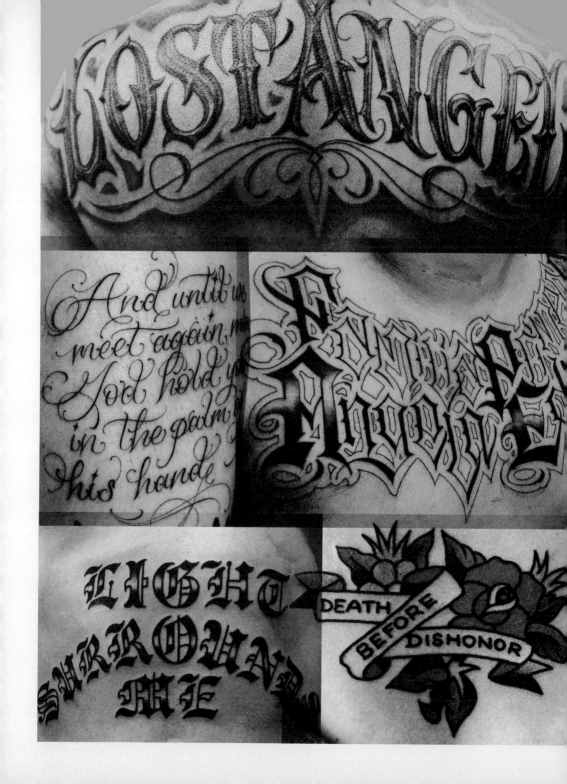

FOREWORD

B.J. Betts

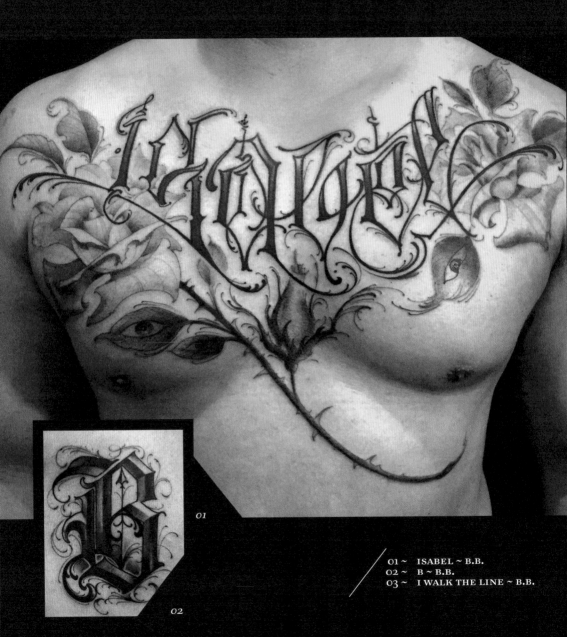

01

02

01 ~ ISABEL ~ B.B.
02 ~ B ~ B.B.
03 ~ I WALK THE LINE ~ B.B.

Thankfully my grandmother saved everything. I remember snooping around my grandmother's basement when I was really young and finding a lot of old handwritten letters from my great-grandfather. I took a few of those letters and tried to copy the different fonts and strokes that I saw. From them, I began to study where letterforms stopped and started, analysing the style and being transfixed by what I saw where the pen ran out of ink and was re-dipped so a line could be continued.

In the 1980s, I was drawn to the graffiti scene. That was really my first exposure to wild, abstract lettering that didn't seem to follow any rules. Like with my great-grandfather's letters, I spent all my time drawing and trying to recreate my own system, always trying to make sense of it all.

When I first started tattooing, lettering was largely ignored. The focus was on the image. Any associated words came second. I found myself looking at flawless, super-clean tattoos, scanning for any flaw and being dismayed to find a constant misstep: the lettering.

My eye, trained by my grandfather's letters and years of graffiti obsession, viewed this as an opportunity.

There were definitely a few tattooers who excelled in lettering – those who, at minimum, had a background in sign painting – and their tattoos always stood out and looked 'right' to me. As I followed them, I also tried my best to pay extra attention to the lettering in a tattoo. I wanted my passion for letters and words, born from my interest in other mediums, to be reflected in tattoo. Subsequently, I became the guy other tattooers would ask to draw some lettering for an upcoming tattoo.

To improve, I spent lots of time at the library, sifting through obscure calligraphy books and learning as much as I could about fonts. I wanted to be able to bring the same emotion others were conveying with image to my composition of a word.

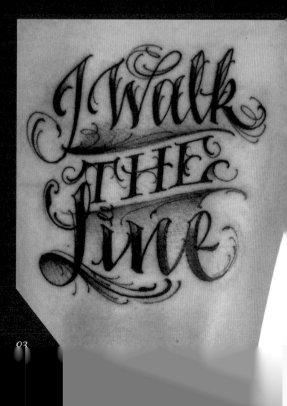

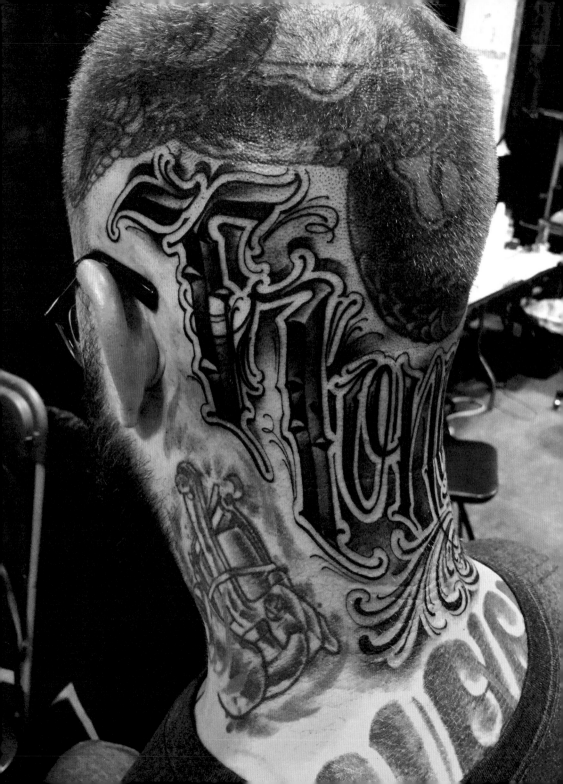

Over the years, lettering has evolved as quickly as tattooing has allowed. Today, it seems the old roles have reversed: lettering is the primary image, and the rest of the tattoo is secondary. The cool thing is that it remains, like the words on my great-grandfather's letters, born from the hand – no digital manipulation, all pure human ingenuity.

This book explores the glory of tattoo hand lettering from tried-and-true block fonts to newfangled forms. I hope it sparks the same intrigue in readers as the old letters did in me.

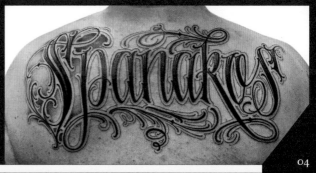

02

03

01

01 ~ HONOR ~ B.B.
02 ~ H ~ B.B.
03 ~ LIVING IS EASY... ~ B.B.
04 ~ SPANAKOS ~ B.B.

INTRODUCTION

Andy Cruz

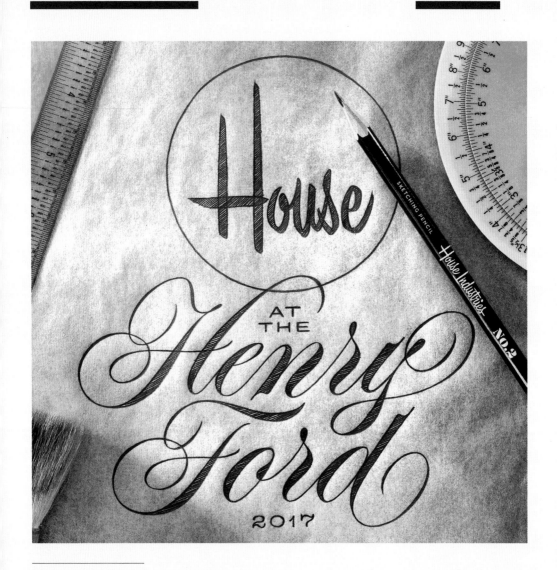

Promotional material for 'House Industries: A Type of Learning' at the Henry Ford Museum of American Innovation, 27 May to 4 September 2017.

Rewind your day and try to count how many times your brain processed letterforms before reading each little one that built this sentence. Whether in print, paint or pixels, the art forms (and each letter is itself a work of art) translate our shared languages into an inescapable, always growing, living thing.

I knew Mr William Joseph Betts before either one of us knew what the hell a font was. Yet we bonded over Bugs Bunny cartoon lettering, BMX logos and the type on Black Sabbath album covers. At a young age, we found ourselves co-conspirators in the pursuit of form. I met B.J. when I was a fourteen-year-old Delaware skateboarder at a technical high school who liked to draw and was trying to figure out this oxymoron called 'commercial art'. B.J. was a senior tasked with sharing what he knew about ruling pens and red sable lettering brushes with my freshman class. At seventeen the dude rolled into 'shop' with a fur coat, Cazal shades and a sketchbook of graffiti that should one day be in some uptown art institution's permanent collection. We were in a trade school, and though we didn't know quite how to express it then, we had begun a process of taking that most blue-collar of ambitions – a trade – and involuntarily transforming it into the making of art.

It was the early 1980s and we quickly realized that there was 'art' in painting signs with One Shot lettering enamels as much there was in setting type on this new robot called a Macintosh. But more interesting than pulling a brush or pushing a mouse was the call of adolescent subversion. Like when B.J. showed us all how to make a Design Marker™ work like a can of Krylon® spray paint – when we should have been practising hand-drawing the entire alphabet in Helvetica. Of course, the lesson he instilled was how to take traditional techniques and use them as camouflage to develop a new sensibility. A sensibility informed by personal interests and subcultures – punk rock, hot rods, Japanese monsters – that inspired this lower-middle-class Delaware teenager, in particular, to be creative. He had an impact on me that only an artist can. And in the process he reinforced that invaluable truth: once you know the rules, you can break them at will.

B.J. and I lost touch after high school. I took a path that turned letterforms and glyphs into fonts that communicate on several planes of the design world. The tattoo gods set different stars in motion for B.J. After high school he joined the US Navy and charted a course to becoming the script savant of modern tattoo lettering.

And it's in B.J.'s letters etched into human forms that we see a poetic humanism drawn by his hands. Hands that combine a technical prowess and an emotional connection that almost subliminally identify side effects of our cultural conditioning. You might not be able to classify a bifurcated serif, but the second you see one you know you're in for something with a western vibe or you're being patched into a biker gang. So while the origins of typographic terms and design jargon are fun additions to anyone's vocabulary, what B.J. and I have always found more appealing is the blue-collar approach of delivering cultural references in alphabet styles that reveal deeper meaning. And it doesn't get deeper, or more blue-collar, than needling ink and form onto skin.

There is always flow in hand lettering words – especially when rendered onto flesh.

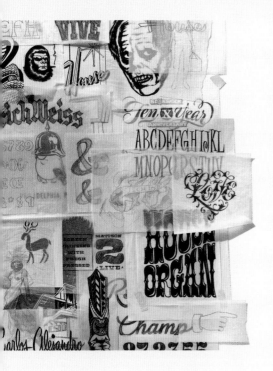

The cadence of alphabetic forms in the hands of a skilled artist can make something that looks cool on a piece of paper truly come to life on a human body. A corporeal alchemy. And what is alchemy but the taking of something of lesser value and turning it into something of greater value? The alchemy on the following pages is informed by a youthful rebellion, fluent social signalling, and an aesthetic proclamation of faith and endearment on the body. It is everywhere in this collection of gifted artists who have been kind enough to share their work and canvas in this book.

Andy Cruz

Andy Cruz
House Industries

Left: Children's blocks modelled after the House Industries factory logo.

Above: A collage of process sketches for various House Industries projects.

Right: Promotional artwork for a font set based on punk letterforms from House Industries.

TATTOO LETTERING:
A BRIEF HISTORY

Nick Schonberger

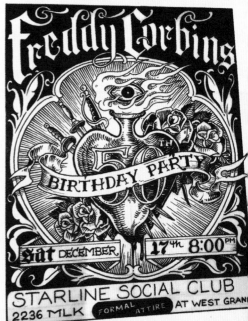

These examples of tattoo lettering on promotional posters by Scott Sylvia exhibit variations of traditional and West Coast styles.

While it is difficult to pinpoint when the first letters were tattooed on a body, this much is clear: sailors and explorers have inked their bodies with initials, names and other written reminders of homeland for centuries.

Thanks to Sailor Protection Certificates, a sort of employment passport issued to American seamen from 1796 to 1818, we know that by the late 18th century, tattoos featuring letters were, without a shadow of a doubt, common. Extant tattoo flash (design source drawings) from the latter half of the 19th century confirms the regular employment of lettering in recurrent European and American tattoos. Slowly but surely, tattoo lettering has matured from a rudimentary beginning into something with a fully emotive form vocabulary.

How did this happen?

In some respects, the trajectory of tattoo hand lettering mirrors the evolution of tattooing itself. At first, both the images chosen and the tools at hand were simple. Complexity comes over time, and at certain milestones. For example, the proliferation of lithography in the 19th century accelerated the depth and breadth of visual culture, and almost simultaneously, tattooing was shifting from hand poke to electric methods of application (the first patent for a tattoo machine was filed

in the 1890s). This meant that not only were there more pictures and sayings to consider as tattoos, but the very application of them was keeping pace too.

That's the brilliant thing about tattooing – it's almost always instantly current.

While at heart a hand craft (tied in history to sailor crafts like scrimshaw), when mastered tattooing becomes an art. It allows for experimentation of line and shadow, and of colour and negative space. In short, tattooing is a near-perfect medium for stretching the limits of perceived possibility and of aesthetic imagination.

Nowhere is this more clear than in tattoo lettering. The letter A can change, literally, from the hands of one tattooer to another depending on artistic background or graphic leaning.

The variety of tattoo hand lettering is inescapably linked to other like-minded pursuits – including sign painting and graffiti, brilliant artistic outlets that have both jumpstarted the careers of pioneering tattooers, ranging from Amund Dietzel in the mid-20th century to Mister Cartoon today. While the trade tools might be different, the lessons of composition, balance and legibility are shared. The rules carry over,

and the influence of different practices is felt on tattooing in different eras.

This is true not just of image, but also of style. By the 1950s, when what's known as traditional tattooing had been codified, lettering was either block or simple cursive. Yet in the decades that followed, as the tattoo industry branched into new, distinct niches, those blocks and simple cursive letters became more varied too … at each step connected to shifts and developments of style.

From the cholo culture of Los Angeles, the West Coast style emerged in the 1970s. Offshoots of that include a more refined script style and the expressive calligraphic style. The influence of graffiti, particularly in the 1990s, gave rise to a particularly high-impact model of tattoo lettering. And, finally,

a new hybridized style that can only be defined as New School arrived in the new century.

Like everything in tattooing, these styles draw from the visual culture of the time. But unlike many contemporary arts, the styles remain tied to the hand. In very few cases are fonts digitized and stencils laid out via Photoshop. Instead, tattoo lettering is predicated on mastering what shapes and line weights work best and most naturally with both the word formed and, ultimately, the area of the body it decorates.

This book shares the ins and outs of tattoo hand lettering, exploring how styles formed and how fonts are created. It serves as equal parts conversation and guide, illuminating the genesis and the future trajectory of one of the last great hand crafts.

Flash sheets by Wisconsin-based C.V. Brownell, c. 1906. These are indicative of a period of tattoo lettering where legibility was the biggest consideration.

Original script lettering by B.J. Betts.

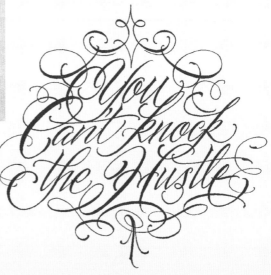

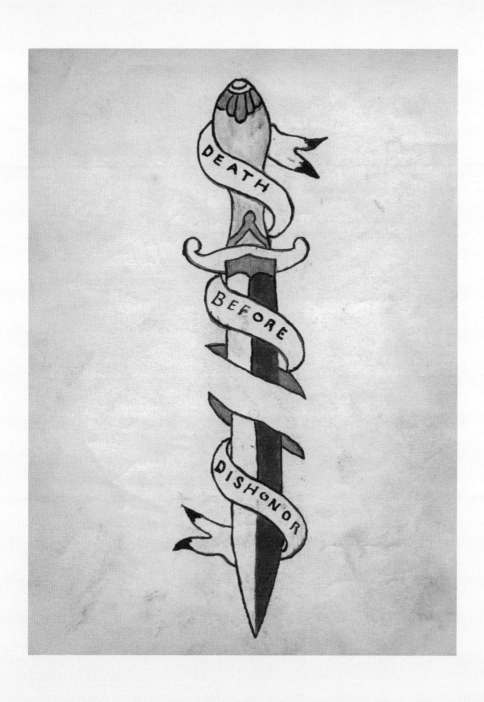

BREAKING DOWN THE TATTOO

B.J. Betts

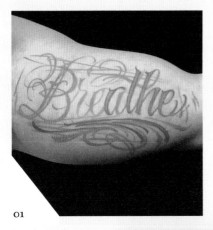

I'll be using this as an example of a tattoo that has been drawn directly on the skin; the before and after process; and how things can be, and usually are, changed while you're working as you see that more space can be filled in as necessary.

01

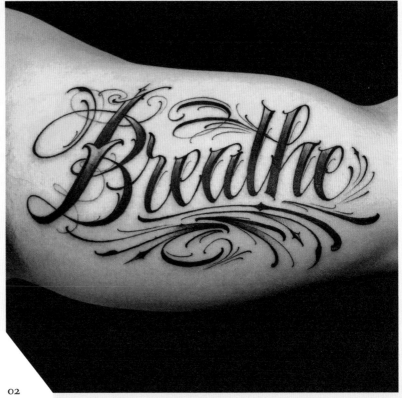

02

'BREATHE'

- Start by roughly sketching/drawing your idea. It can be really rough, as it's usually just the initial design. If it needs a few layers of drawing and reshaping, I'd recommend starting with a lighter-coloured marker or pen, and building it up a little until you're comfortable with the design. Usually, a darker-coloured marker or pen isn't recommended, as you'll be tattooing over it and might not be able to easily tell which part you have or haven't tattooed yet. Generally, this won't last as long on the skin as a traditional stencil, so this probably isn't for artists just starting out.

- Usually a top and bottom guideline is roughed in and the space that will be tattooed is mapped out. Frequently, lettering will be used as a space filler, and drawing ideas directly on the skin works better. However, if you have time, preparing a drawing and getting your ideas worked out on paper first is always a great idea.

- Pay close attention to spacing, which is extremely important to any successful lettering design. You also want to really try to make sure the same attention is paid to every letter, as consistency is very important.

- Mixing things up and keeping the eye moving throughout the design is also important, so adding flourishes and shading is always a plus. But be careful: there's a fine line between not enough and way too much.

- Using different line weights is very helpful for keeping the image clean and interesting. It also gives the design that hand-drawn look that is hard to replicate.

- It's best to use flourishing and extra-decorative lines as continuations of the letters being used, as you can see in the B and the lower case t and h combination. This is even more the case if you have a letter with an extender, for example y, g, p or q.

- Once you feel you're happy with the initial layout, give the design a good once-over, and if you feel it needs a little more attention in certain areas, go for it. Just remember, you can always add, but you can't so easily take away.

01 ~ BREATHE ~ B.B.
02 ~ BREATHE ~ B.B.

'ALWAYS HAVE, ALWAYS WILL'

- This is a great example of the importance of spacing when you have designs with multiple words or longer phrases. It can easily get away from you and can quickly become disastrous.

- As mentioned on the previous page, line weight and consistency are very important. The tattoo can gain a completely different look and feel with just a few thicker strokes, as you can see with the first capital letters of each word. They have similar strokes and aesthetics and complement each other nicely.

- Using the entire area available for the piece is also an integral part of a successful design.

- For lettering that's more on the finer-line side of the tracks, keep in mind how things will age. Give the tattoo room to breathe and, more importantly, give it room to live.

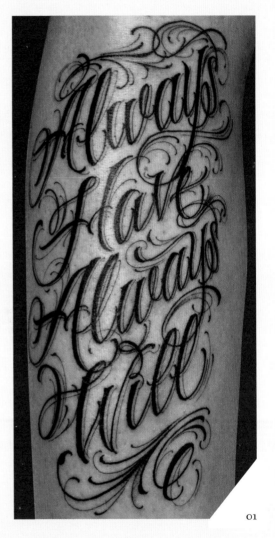

01

01 ~ ALWAYS HAVE, ALWAYS WILL ~ B.B.
02 ~ HAWKINS ~ B.B.

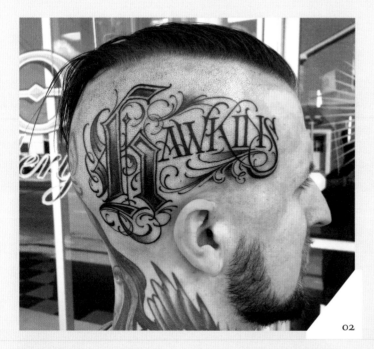

02

'HAWKINS'

- There was a good bit of room above and below the 'awkins' part of the name, so adding some flourishes was a great choice and very complementary to the overall design.

- Using different fonts can be a little tricky, so make sure they're compatible. Along with proper spacing, that's another area that can make or break a tattoo or design.

- Adding some shading is a great way to shape the whole design as well. It can give the illusion of a banner or can be used to sculpt a few lines and turn it in a certain direction without necessarily using a hard line to do the job.

- With lettering, when there's no supporting image, it's up to you to give the viewer the right feel for the design. So choosing the proper font for the job is like a painter using the right brush or a chef the right knife.

- Again, looking at the entire area that's available and making the best use of it is important. Visually, looking at the H, there's a great deal of room on that part of the head, so choosing a more ornately designed letter was an easy choice. It also gives the tattoo a very regal feel.

THE STYLES

Letters make words. That much is obvious. Words, of course, have meanings, and these convey both distinct definitions and nuanced connotations. When a word is chosen as a tattoo (or in any pictorial application, for that matter), its essence, its spirit, must be carefully considered.

That is where lettering comes in, and where the pure humanity of hand lettering has superb value. Because in the process of creating the graphic image of the word, letterforms are what really allow the exact tone desired to come through.

After fifteen-odd years of tattooing, I've produced countless lettering tattoos. Each client comes with the word and a story, and my job is to translate both into something that will stand the test of time. I'm always pushing myself to stretch my imagination, to find the perfect look for a given job, and more often than not I start with what are, to me, the fundamental styles of tattoo lettering: traditional, West Coast, script, New School and calligraphy.

02 ~ *West Coast*

The following section of the book introduces each of these styles at bedrock level. These pages offer historical and contemporary context and direction for mastering the basic principles of the styles.

The traditional style – or 'pike' style, as it's commonly referred to in the tattoo industry – has deep historical roots. It is the first choice when adding any accompanying words to a traditional design. I like it because its forms are strong, bold, straightforward and easily read. The latter, of course, is extremely important, not only in lettering, but in the traditional style of tattooing.

The West Coast style has always been one of my favourites, not just visually but also graphically and artistically. It speaks volumes. In origin, the forms are very neighbourhood-specific – even down to the point where certain letters may be recognizably associated with certain areas of Los Angeles or with crews that ran a specific block. I have worked on learning as much as I can about the style, and have been extremely fortunate that so many legendary artists (many of whom are highlighted in this book) have shared their personal stories and accounts of this style. Visually, it is very angular and aggressive, but simultaneously a thing of beauty when done right (and with respect).

01 ~ *Traditional*

The script style is another one of my favourites. I've always been drawn to this style and it's very reminiscent of a time when penmanship, a lost art in the present day, was highly regarded. Script tells an elegant story, but with just a few changes in the stroke of a line it can give the reader an entirely different feel. It's applicable to most designs and when done properly or even slightly better than that, it really can't be beat.

05 ~ *Calligraphic*

Finally, the calligraphic style is also near and dear to my heart. I picked up a Speedball lettering book one summer when I was young and it changed my life for the better. This style of lettering is often used when the artist wants to make a bolder statement, while conveying, dare I say, a regal feel. It speaks of an older time when a pen nib and a bottle of ink were the norm and not an electronic option in the tool section of a computer program. It's generally one of the tougher styles to get a good handle on, as a less than okay version will stand out as such a mile away.

03 ~ *Fancy Script*

New School lettering style is less obviously defined than the others. It takes on many shapes and forms (often ornate in nature), yet does have some basic shapes, rules and guidelines to follow. Mastery of the root of the style allows any letter to be reshaped and twisted to fill in a designated space more cleanly than other styles, whereas a nice cursive could be compromised by a tight plot.

Photo galleries highlighting a selection of my favourite tattoo artists illuminate the application of each style too. These illustrated examples are particularly useful in considering how experimenting with the foundational forms allows for the creation of unique spins on the structure. Each section ends with a conversation with a tattoo artist who has helped me progress my own lettering – their take on the process or on the principles of a style will be critical to anyone aiming to perfect their work. In presenting this collection of material, I hope that this guide helps to capture the power of making letters form more than just words … but instead, perfect, expressive statements.

04 ~ *New School*

INTRODUCTION

Examples of early tattoo flash by C.V. Brownell, c. 1906. Many tattoo designs of the period carry military themes and were accompanied by names of loved ones or patriotic phrases.

What constitutes traditional tattooing? Commonly, this designation describes tattoos that follow an American or European custom, with the style revolving around bold, clean lines and sharp, full shading. Originally, themes included those conveying sentiments of love and loss, and professional or military affiliation, and branched out over time to encompass hobbies, statements of superstition and more.

Compositionally, traditional tattoos are built on depictions of clear subjects. While these have progressed (anything now rendered with bold lines and sharp, full shading can be described as traditional) there are historical antecedents: animals, hearts, gravestones, ships, religious symbols and figures. Each hits a theme and each conveys a thought.

That thought, however, may often require clarification. And that is where lettering plays a part in traditional-style tattooing. Every ship needs its title. Each lover needs his or her name. Every lost comrade requires an appellation. The list goes on, but can include phrases that drive an attitude, such as 'Good Luck', or that share a belief, such as 'Hold Fast'.

For any of these, space within the composition of a tattoo is established. In some instances, such as a mourning tattoo comprising a tombstone, the design itself clarifies the space. In other tattoos, the employment of a banner stipulates the position and ultimate shape of a word.

Most simply, the letterforms in traditional tattooing carry the same direct, strong lines as employed in the associated graphic elements. Privileging legibility, the characters employed, as noted above, add context. For example, text will clarify that the object of mourning is 'Mother' or indicate the name of a portrayed pet.

Despite a relative lack of variety in letterforms in traditional tattooing, there is nonetheless a need to act critically when applying them to a design. Tone can be conveyed via line weight. Sensitivity is required when rendering something like 'The Sailor's Grave', a thematic design picturing a sinking ship and often inked to articulate the plight of the seafarer. In contrast, a touch of optimism might mark the letterforms in a 'Homeward' tattoo, or a sense of subtle sarcasm in the depiction of 'Man's Ruin!' (a dangerous combination of booze, gambling and women).

Traditional tattoos can be traced back to the late 18th century, explicitly to mariners, and from there the style developed from a rudimentary to a more sophisticated articulation. Such names as C.H. Fellowes, August 'Cap' Coleman, Amund Dietzel, Owen Jensen, Percy Waters, Bert Grimm, Tatts Thomas, Bob Shaw, Paul Rodgers and Norman Collins all contributed to its growth.

As time passed, letterforms, much like the tattoos themselves, became sharper and equipment more precise. The function – as contextual aid – has remained, but the toolkit, if you will, has expanded. So, while text might be rendered solely in block letters, the forms expand to include heavier, half-shaded shapes and more jaunty lines. Cursive is another option, often used when signing flash sheets, but tends to be more sparingly employed.

Artists like Bert Krak are expert in combining block shapes to convey specific emotion. His output exemplifies what lettering means in contemporary traditional tattooing – an understated ingredient of a design that nonetheless must be applied with great care.

More examples of early tattoo flash by C.V. Brownell, c. 1906. Note that the lettering within these is all housed in banners, a common device in the traditional style.

HOW TO GUIDE

Traditional letterforms start with a rough sketch of the basic shape. Take it slow and really think about the process and how each letter will serve the final layout. While the basic components of the style are simple, it takes practice and dedication to perfect.

- Think about the root shape of a letter. You know what the letter <u>A</u> looks like, right? You know, three lines? An upside down <u>V</u> with a line through the middle? With traditional tattoo lettering, there is a bit of artistic freedom. Make sure it's still legible as the letter <u>A</u> after you start to reshape it.

(A)

- As you can see with the circled sections, the top serifs are shown in two different variations. Both work just fine, but I'd make my choice based on a few relevant elements, such as what the word or phrase is, and whether it's going to be accompanying an image or used on its own.

(AAA)

- Don't forget to take all the space you're using into consideration, not just the immediate vicinity of the word or phrase. Look at the entire area and figure out the best way to fill it in a little better and make it more pleasing to the eye.

(Hate vs Love)

- If there's a letter that can be used to help that along, by all means go for it. Some letters, such as <u>R</u> or <u>M</u> or <u>N</u>, can be used and exaggerated to add a small flourish or some other decorative line, as shown in this 'Dumb & Dumber' example.

(Dumb & Dumber)

ABCDEFGH
IJKLMNOP
QRSTUVW
XYZ?&!
1234567890

- As with all lettering, consistency is important. Make sure all the strokes are on the same plane. Legibility is crucial, so don't add any nonsense.

- Here there are flourishes and decorative strokes through some of the letters, such as C and D.

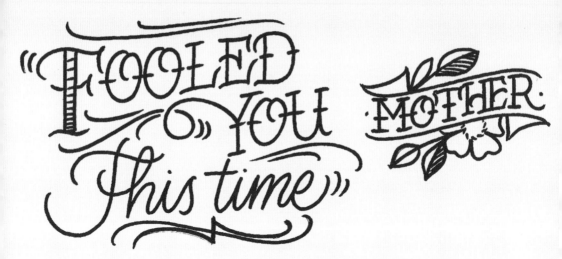

"FOOLED YOU This time"

MOTHER

MOM

SMILE NOW Cry Later

IN MEMORY OF

Examples of traditional
block and cursive fonts
used in phrases typical
in American tattooing.

"ROCK OF Ages"

Sailor's Grave

IN. Loving ·MEMORY·

Semper Fidelis

HOMEWARD
Bound

BORN TO Lose

Hot Stuff

HOT STUFF

Mama
TRIED

Examples of traditional
block, cursive and pike fonts
used in phrases typical in
American tattooing.

DEATH BEFORE DISHONOR

FAIR *Winds* FOLLOWING *Seas*

Rose of NO MAN'S *Land*

"*True*" 'TIL *Death*

TRUE *Love*

LOVE
MOM

LOVE
HATE

FATHER

N.Y.C.

EAST
COAST

WEST
COAST

Examples of traditional block, cursive and pike fonts used in phrases typical in American tattooing.

CARPE DIEM

HOLD FAST

SINK ·OR· SWIM

TRUE
UNTIL
DEATH

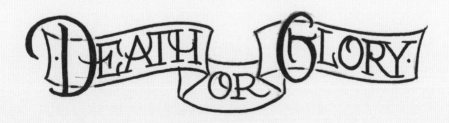

DEATH OR GLORY.
·OR·

GALLERY

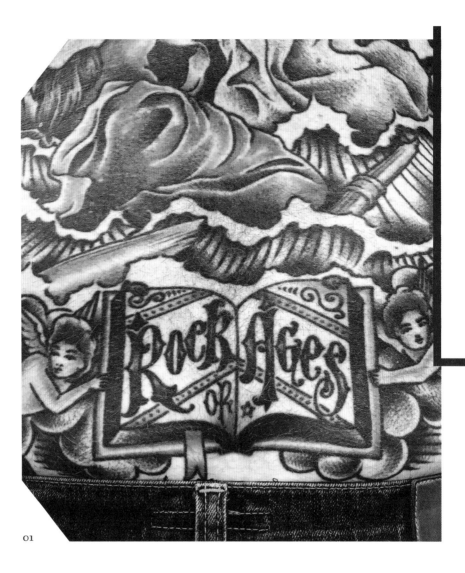

01

02

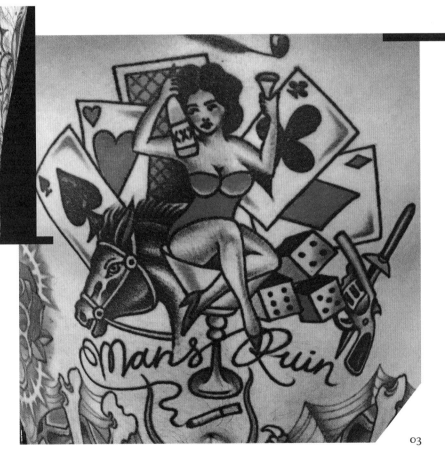

03

01 ~ ROCK OF AGES ~ S.B.
02 ~ MADELYN ~ S.B.
03 ~ MAN'S RUIN ~ S.B.

01

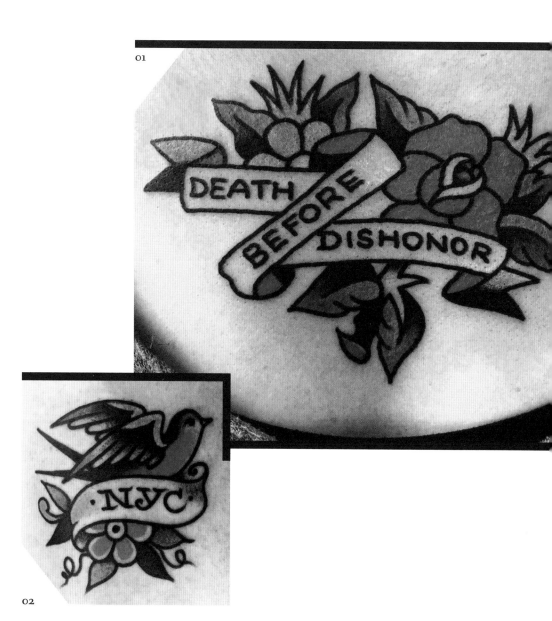

02

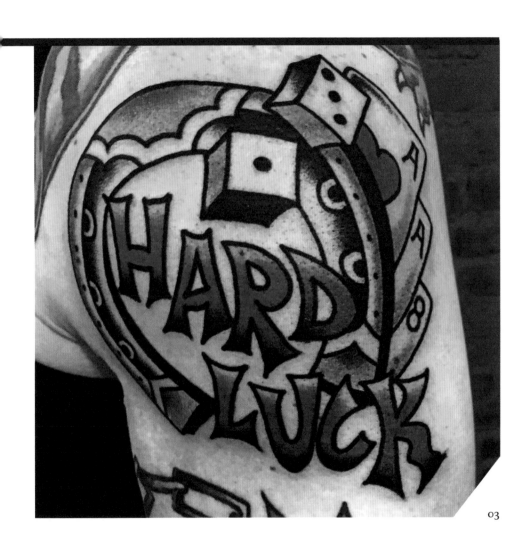

03

01 ~ **DEATH BEFORE DISHONOR ~ S.B.**
02 ~ **NYC ~ S.B.**
03 ~ **HARD LUCK ~ S.B.**

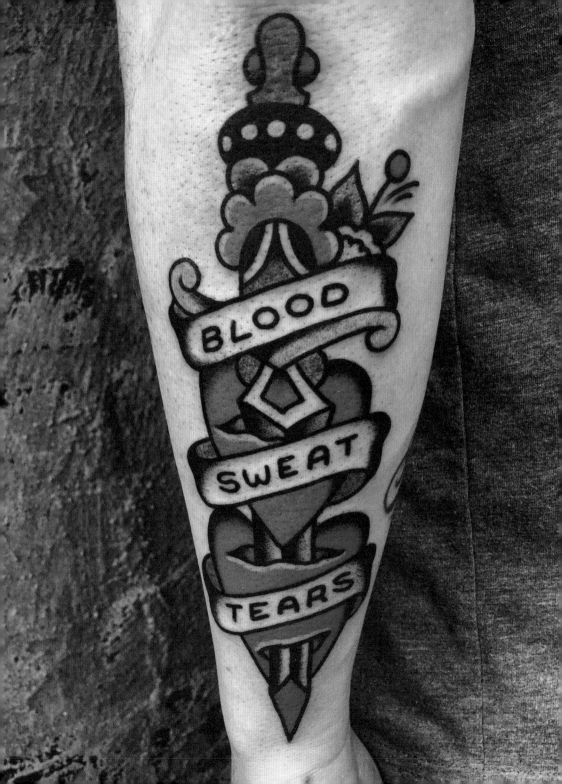

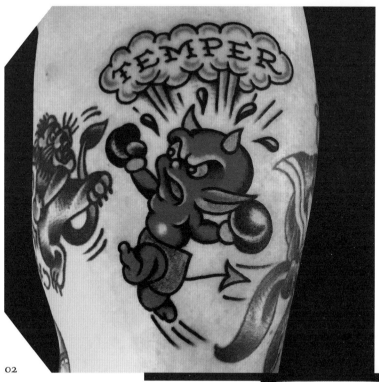

02

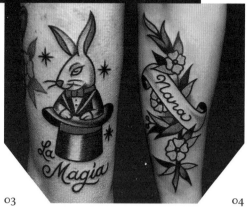

03

04

<01

01 ~ BLOOD SWEAT TEARS ~ E.Q.
02 ~ TEMPER ~ E.Q.
03 ~ LA MAGIA ~ E.Q.
04 ~ NANA ~ E.Q.

01

02

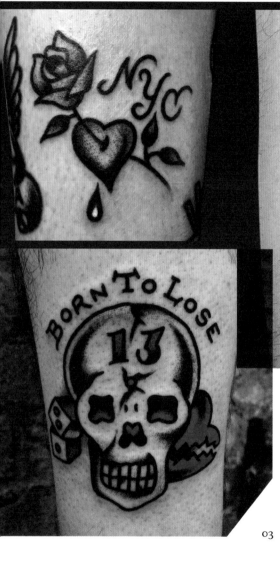

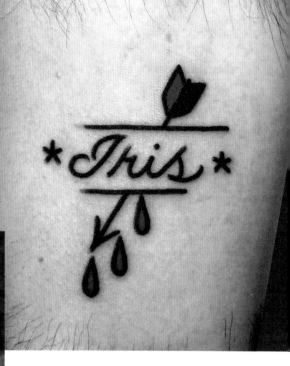

03

04 ▷

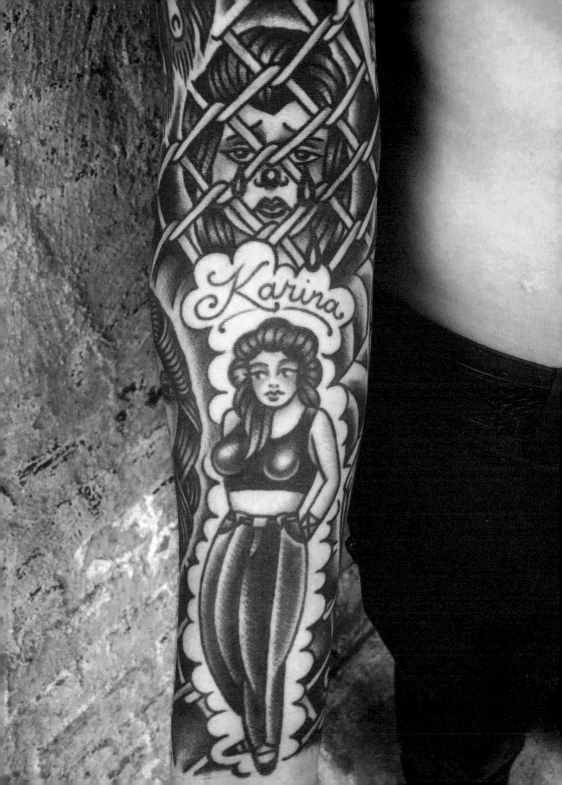

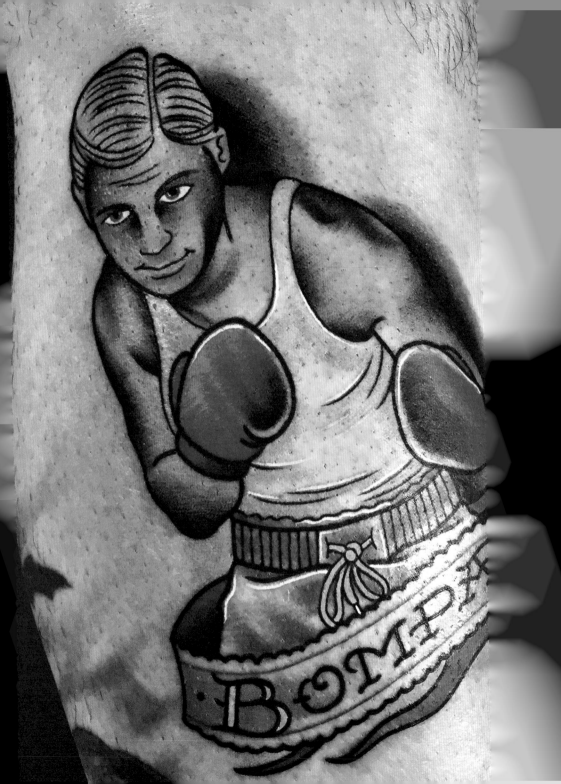

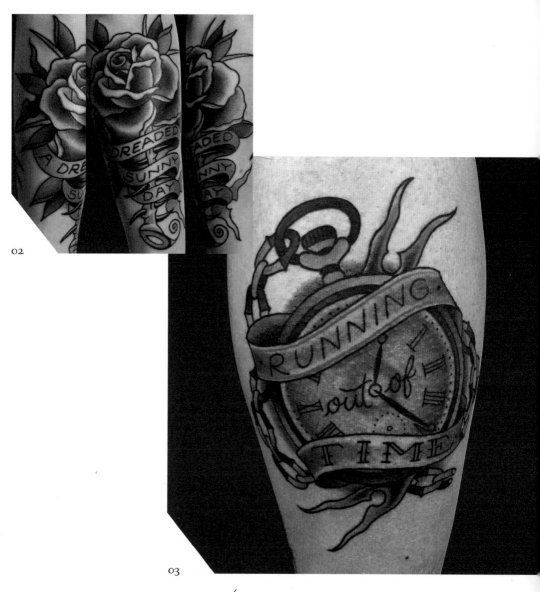

02

03

01

01 ~ **BOMPA ~ D.S.**
02 ~ **A DREADED SUNNY DAY ~ D.S.**
03 ~ **RUNNING OUT OF TIME ~ D.S.**

01

02

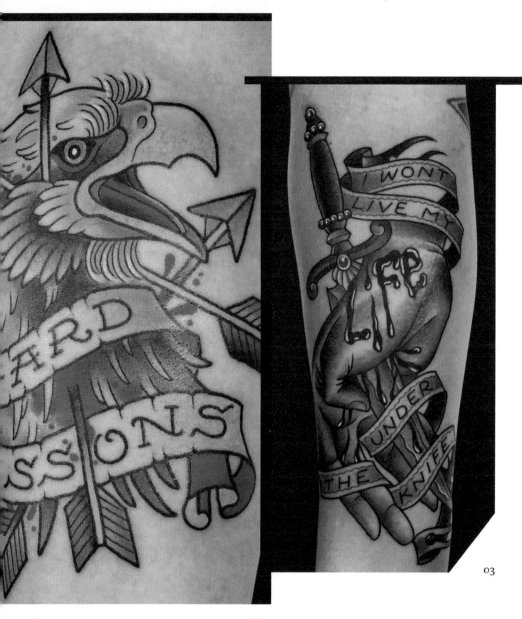

01 ~ MY TRUE LOVE ~ D.S.
02 ~ HARD LESSONS ~ D.S.
03 ~ I WONT LIVE MY LIFE UNDER THE KNIFE ~ D.S.

INTERVIEW

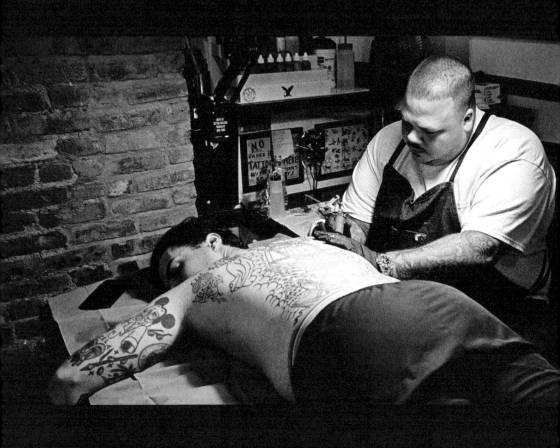

Born on 12 July 1977, in Hollywood, Florida, Bert Krak now resides in Queens, New York. He co-owns the world-renowned Smith Street Tattoo Parlour in Brooklyn, where his take on traditional tattooing helps to define the modern street shop – recreating classic iconography and reinterpreting contemporary motifs in a classic style.

Krak began tattooing and painting in 2000. Since then, his heavy lines and distinct colouring have become known around the world. While he may not be by definition a lettering tattooer, his approach to words pushes traditional lettering into the modern era.

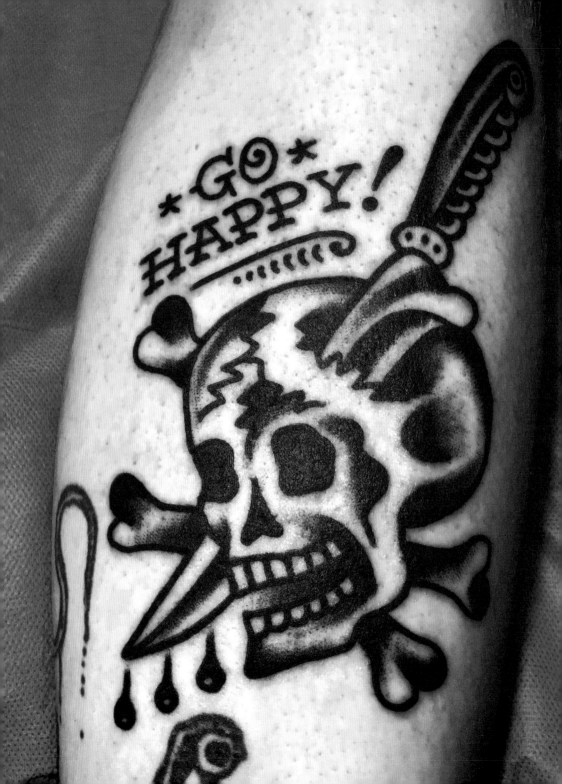

BB ~ How would you define traditional tattooing?

BK ~ I would define traditional tattooing as a tattoo that's done in a traditional style – meaning, using a proper outline, black shading whether there's colour or black and grey. Ultimately, the image you're using or tattooing will define that, because if it's not really a classic image, then what would really make it traditional?

BB ~ What different parts do the outline and the shading play in a traditional tattoo?

BK ~ Well, whip shading would give you that traditional look…

BB ~ Whip shading?

BK ~ Whip shading is when you 'whip' the shading, shading it faster. Gives the shading a peppery look. In my opinion, that's the traditional style of shading.

BB ~ Why was it done that way?

BK ~ Back then, tattoos were done fast and efficient and that was the way it looked because of that speed – trying to cover as much area as fast as possible. You know, there were people lined up waiting for tattoos, and you had one guy that did the outline and then the customer went down the line to the next tattooer and he did the shading and colouring. Also, traditional tattoos have heavy black, but not too heavy. Don't overdo it with the black.

BB ~ How does lettering play a part in traditional tattooing?

BK ~ A lot of times, you would add the names of loved ones; or with military tattoos, you'd add the name of your ship or unit. In a lot of traditional tattoo designs, there are ribbons or banners that were there for a reason: to add a name or a phrase. Actually, times were a lot simpler back then, and the lettering was pretty straightforward. Not many long phrases from what I've seen.

BB ~ When you first started tattooing, why were you drawn to that traditional style? Why not New School or any other number of styles?

BK ~ The guy that taught me how to tattoo, Danny Knight, that's the style he was into. At first I didn't really understand, but the more I got to know Danny and got to understand what was going on, I realized that to me, that's what a tattoo is supposed to look like, and I wanted to do tattoos that look like tattoos, you know? I just decided that I'm going to do what customers ask me to do, but that anytime I have the opportunity to do something that I want to do, I'm going to try and steer them in that direction.

01 ~ GO HAPPY! ~ B.K.

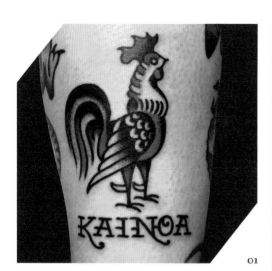

01

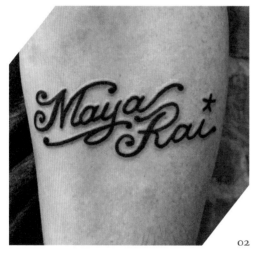

02

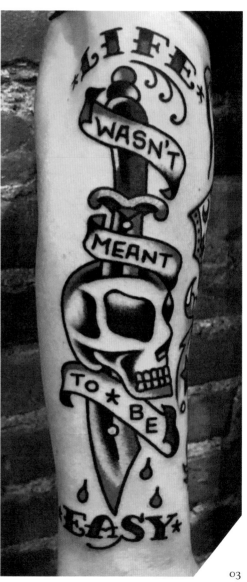

03

BB ~ Why do you think that traditional tattooing has endured?

BK ~ You know what, I think there was a time that it wasn't that way. I was talking to Bob Roberts [the Los Angeles-based tattooer who learned his trade at the Pike in 1973] about that. Bob said that he was at a tattoo convention in the 1970s and put out a bunch of traditional flash sheets and the other tattooers thought he was crazy for putting that out there for the customers. There was a time when customers didn't want that at all, you know? They didn't want that old style of tattooing, and who knows, maybe there will be a time when it's that way again. But for me, that's the look that I'm going for.

BB ~ The consensus seems to be that this also depended on what part of the country you were from. People in Los Angeles, for example, weren't getting the same tattoos as, say, those on the Lower East Side of New York City.

How does needle configuration play a part in not only traditional tattooing, but in the lettering as well?

BK ~ It does play a big part in it. People think that it's only bigger, huge outlines that make it a traditional tattoo.

BB ~ Do you disagree? Would you say that you can do a traditional tattoo with a smaller needle grouping?

BK ~ It all depends on the design, how open it is, and I really think that, from what I've learned and what I was taught, that way back when, I don't think those guys were using really big needle groupings – I think they were using, say, a 4 or 5 needle outliner. Now, they just look so big because it's so many years later and the tattoo is aged. The needle grouping really is about what the tattoo calls for, or whatever suits your style. To me, it doesn't have to be done with a big fat line to be considered traditional. You can achieve the look with a toned-down needle size. Again, it just all depends on the design you're using.

BB ~ When you're doing lettering, whether it's with an image or on its own, what are some things you consider when you're putting the design together?

BK ~ I try to imagine how the lettering is going to hug the design and complement it, and how it will fit on the body part I'm tattooing. From there, I feel like I treat it almost like a math equation, trying to balance it all out so that the lettering doesn't take away from the design, it only adds to it.

01 ~ KAINOA~ B.K.
02 ~ MAYA RAI ~ B.K.
03 ~ LIFE WASN'T MEANT TO BE EASY ~ B.K.

BB ~ What about when it's a standalone lettering design, do you approach that any differently?

BK ~ I do, in the sense that the lettering is the only image to look at, so I make it fit the word or words or phrase I'm tattooing on the person.

BB ~ Do you like to prepare a drawing first or do you draw right on the skin?

BK ~ If I'm in the shop, just because I'm home and I'm comfortable, I will draw stuff on if I'm just doing something small or adding lettering onto an existing tattoo, or whatever. If I'm travelling, at a convention maybe, then I'll just draw it on and it works out nicely. In the perfect situation, I'd rather prepare a drawing and make a stencil.

BB ~ Who has helped to shape your understanding of the traditional style and the way lettering is included in that style?

BK ~ I talked to Tony Polito (rest in peace) a lot about lettering, and his is some of the best I've ever seen. I get to see so much of it come into my shop. Mike Perfetto, he does some of the best lettering tattoos around right now, and can pretty much do any style of lettering or any style of tattoo. I feel like Mike Wilson does some amazing lettering, he has a very interesting approach to adding lettering to a tattoo. Mike's lettering has so much style,

just like Tony and Mike Perfetto. The way they draw and tattoo lettering is exactly how I want mine to look.

I need to mention Eli Quinters and Steve Boltz. Those guys do some amazing lettering. Eli is really amazingly good at names and script and it's so clean. Boltz can actually draw really cool block letters, different fonts and images. Less typographic and more image-based lettering, if that makes sense. He can come up with the designs that involve lettering.

Oh, and one more thing, I can't stress enough how truly amazing Tony Polito's lettering was. Not only did the guy have some of the most stylish traditional tattoo lettering, he could also do the smallest, tightest typewriter-style font. Mike Perfetto refers to it as Tony's brand of typewriter font. He really is the best, and you can recognize his letters from across the street.

BB ~ Do you think that lettering plays a bigger role in tattooing now than in the past?

BK ~ Absolutely. I see lettering tattoos probably more than anything else. I'd say lettering is probably, right now, the most popular tattoo in the world. But there was a time that every person wanted their own name on their arm. I'm getting 'Bert', you're getting 'B.J.', you're getting your last name on you somewhere, and man, I think so many people were made fun of for having their own name on their arm, and were shamed

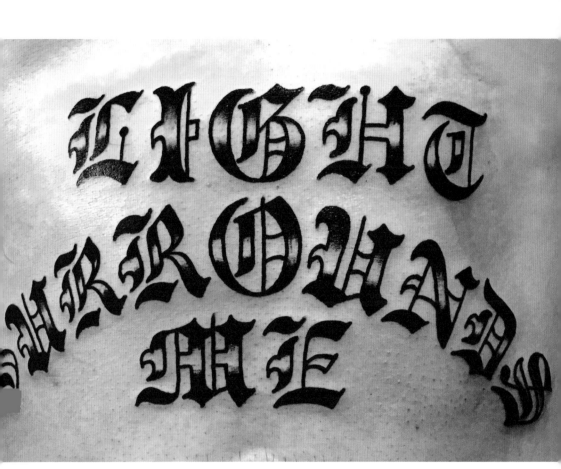

01

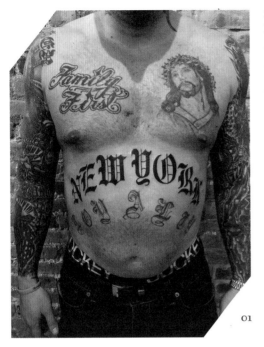

01

for so many years, then the next thing you know, no more name tattoos on the arm. Think about it, when was the last time you tattooed somebody's own name on THEIR arm?

BB ~ Not recently.

BK ~ Right, so now that I brought that up, you miss that, right? How come Mike doesn't get 'Mike' on his arm any more? I want to bring that back. I want people to start getting their name again. I want to do a big traditional Christ head with their name underneath it.

BB ~ Do you have your name tattooed on you?

BK ~ Not my first name, I've got my last name pretty big, and I have my kids' names, but you know what I'm going to do, I'm going to have you tattoo my name on me next time I see you.

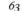

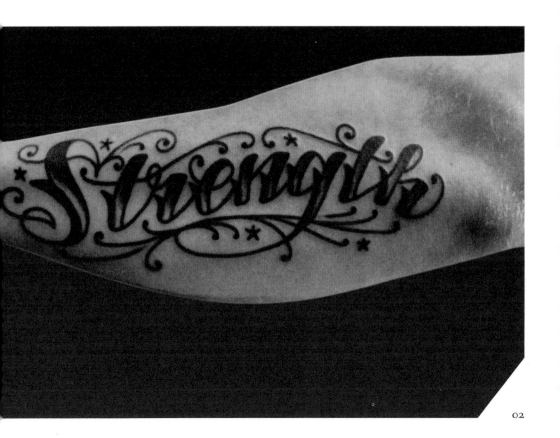

02

01 ~ NEW YORK ~ B.K.
02 ~ STRENGTH ~ B.K.

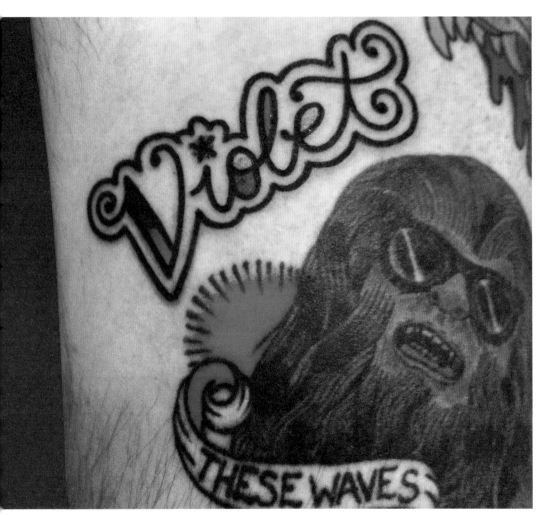

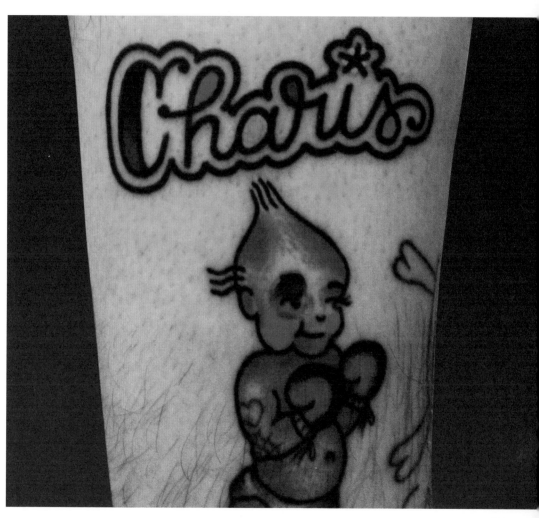

01 ~ VIOLET ~ B.K.
02 ~ CHARIS ~ B.K.

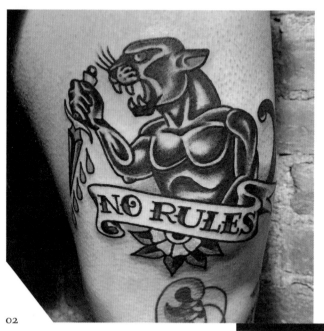

02

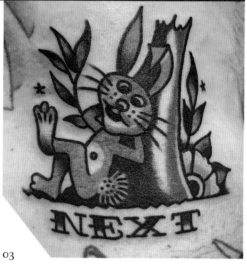

03

◁ 01

01 ~ MICHAEL ~ B.K.
02 ~ NO RULES ~ B.K.
03 ~ NEXT ~ B.K.

INTRODUCTION

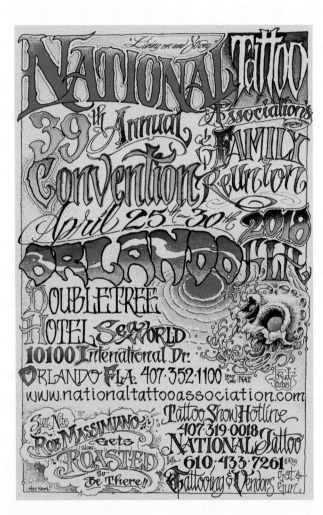

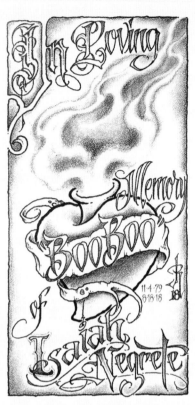

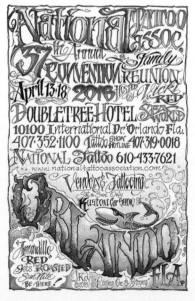

*Above and right: Posters
designed by Jack Rudy for
the 2018 National Tattoo
Association convention in
Orlando, Florida.*

*Top right: Memorial artwork
by Jack Rudy in honour of
the late Isaiah Negrete.*

Greater Los Angeles may well be the spiritual home of contemporary tattoo lettering.

There is great historical precedent: the 'pike' style, an expressive traditional block letter formed with sharp, snappy lines, was codified in the tattoo parlours of (of course) the Pike amusement zone in Long Beach by the likes of Bert Grimm. It's now perhaps the most famous, if not ubiquitous, of all tattoo fonts, but despite the omnipresence of the style it isn't truly tied to LA. Instead, Southern California's home-grown, black and grey style – blending neighbourhood gang writing, religious iconography and realistic depictions – is what blossomed from a local aesthetic to a global phenomenon. Black and grey developed, in some respects, as a counter to the traditional style. So the proximity to the Pike and the bodies that were adorned there provided the spark for something different.

Often called fine line, this type of tattooing was initially done with makeshift equipment (think guitar strings as needles) and bore a distinct look from its detailed lines and lighter shading. While traditional tattoos had an animated, even cartoon vibe, black and grey work strove for realism. Images common in the Chicano barrio neighbourhoods from which the style emerged took precedence, and included incorporation of the stylized writing employed by street gangs and individuals.

While lettering in traditional tattoos served to delineate meaning or subject, in black and grey, by contrast, the letters serve as an announcement. Lettering was used to tell the stories of the wearer – the city, the street and the neighbourhood – with a prideful punch and undeniable panache.

The style gained a foothold in the larger tattoo industry when Don Ed Hardy and Jack Rudy established Good Time Charlie's in East LA. In 1977, Freddy Negrete (widely recognized as the first professional Chicano tattooer) joined the shop's crew. A raw talent who practised what he described as 'joint style', he helped formalize black and grey tattooing and with it opened the aperture for a greater variety of lettering.

Together with Rudy, Negrete shared with the wider tattoo world the potential of Old English fonts and elaborate script – types of lettering found regularly as graffitied tags, known in the region as placas, but until the late 1970s and early 1980s uncommon in tattooing. Later generations, including Baby Ray, pushed the ambition of the lettering as the style matured. Scale increased as application to different body parts was explored, and soon lettering was not an addition to a design but the entirety of a design. But one thing remained: the lettering from Los Angeles' neighbourhoods defined the aesthetic.

Mister Cartoon applied a formal training in sign painting and his street background in graffiti to tattooing in the 1990s. His command of LA's hallmark fonts brought global attention to the West Coast style of lettering and with it propelled fancy script and tough Old English looks from the periphery of tattooing to a globally desired look.

West Coast lettering, with its range of script fonts, progressed tattoo lettering from its mostly one-dimensional beginnings to an emotive future. Far from stagnant, the style keeps evolving and is also critical as an antecedent to almost all of the contemporary lettering styles popular today.

HOW TO GUIDE

This style is definitely a strict, hard font to figure out, but once the baseline rules are mastered it is enormously fun to draw. What I love most about it is the adaptability – it's attractive both alone and when mixed with other letterforms.

- As with most lettering, starting with a rough sketch always helps out, and with West Coast-style fonts, part of the attraction, in my opinion, is the fact that it's done with less preparation and attacked in more of a freestyle manner.

(AAA / BBB)

- Keeping the look of this font a little loose and raw helps convey an attitude, but so too can a subtle refinement – just don't get overly polished.

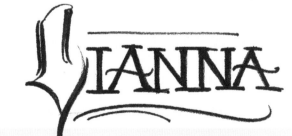

(Love)

- Another unique element of the style is that while mixing upper- and lower-case lettering is frowned upon with other fonts, here it can look amazing as long as line weight is well considered.

(Cianna)

- There are plenty of embellishments that help convey tone within the West Coast style. For instance, adding a drip-like effect helps hammer down the hand-done effect of it.

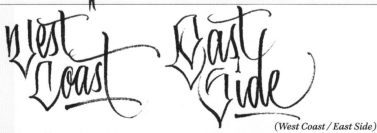

(West Coast / East Side)

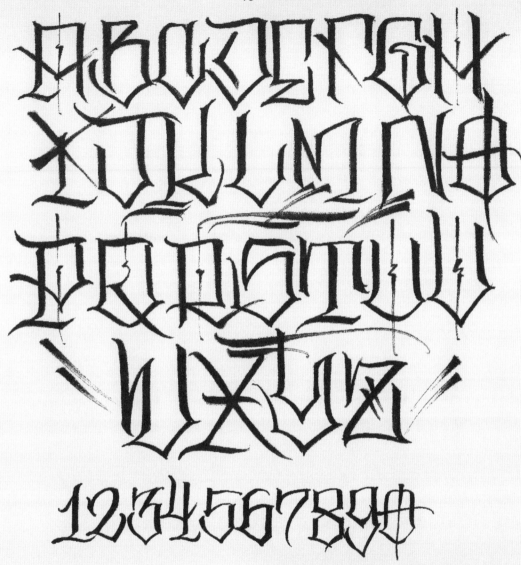

- Keeping with the angular shapes is very important. Although at first glance, it might not look like there is a formula to this style of lettering, there definitely is.

- Adding different coordinate vertical lines through the letters that have more open areas serves a few purposes: it fills in the space nicely and also keeps everything uniform, allowing the lettering to flow nicely.

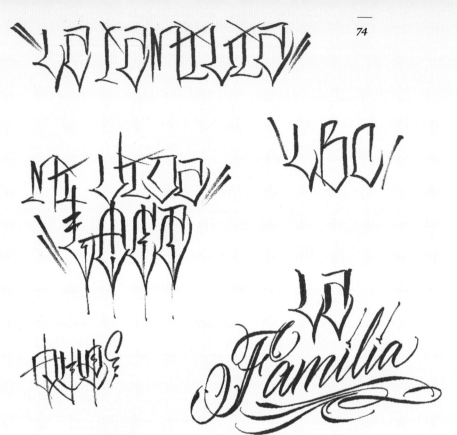

Examples of West Coast-style fonts employed in acronyms, phrases and words typical of the genre.

BOBUX

VENICE

CRENSHAW

Venice

SOUTH CENTRAL

ECHO PARK

HOLLYWOOD

Pasadena

SMILE Now CRY Later

Por Vida

Con Safos

EAST SIDE
WEST SIDE
NORTH SIDE
SOUTH SIDE

POR VIDA!!

Examples of West Coast-
style fonts employed in
acronyms, phrases and
words typical of the genre.

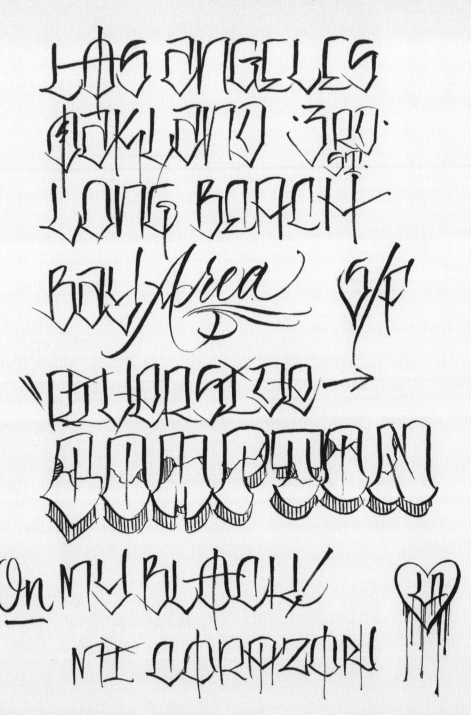

LOS ANGELES
OAKLAND ·3RD· ST.
LONG BEACH
BAY *Area* S/F
RIVERSIDE →
COMPTON
On MY BLOCK!
MI CORAZON

GALLERY

Interview:
Mister Cartoon

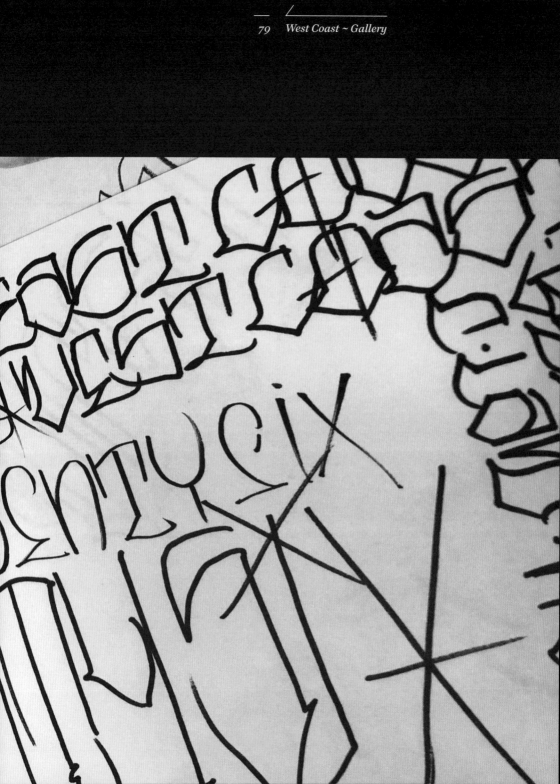

01

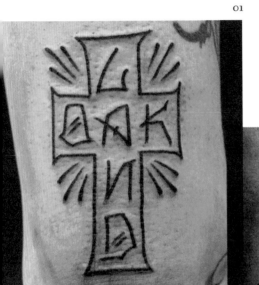

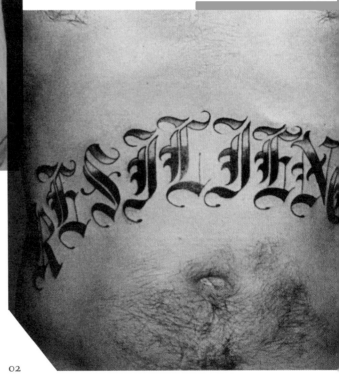

02

03

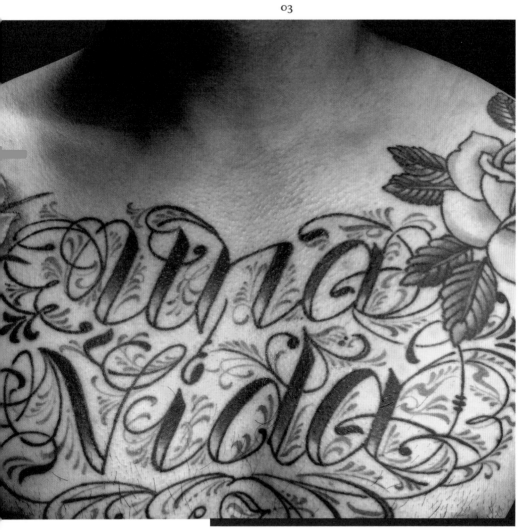

01 ~ OAKLAND ~ F.C.
02 ~ RESILIENCE ~ F.C.
03 ~ UNA VIDA ~ F.C.

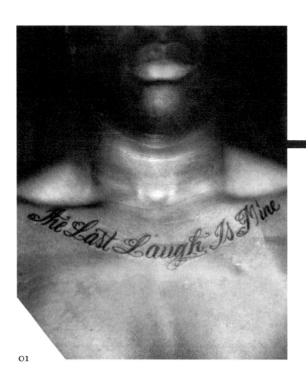

01

02

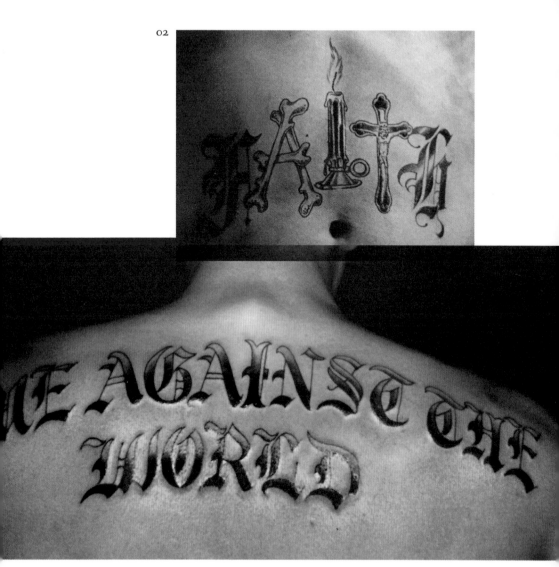

03

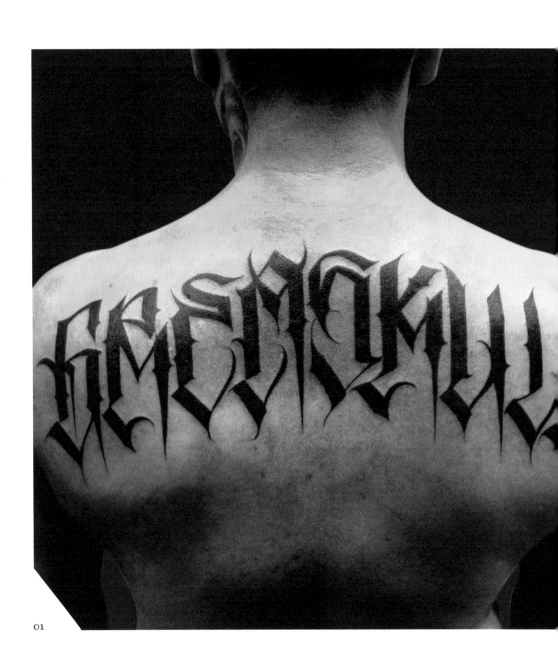

02

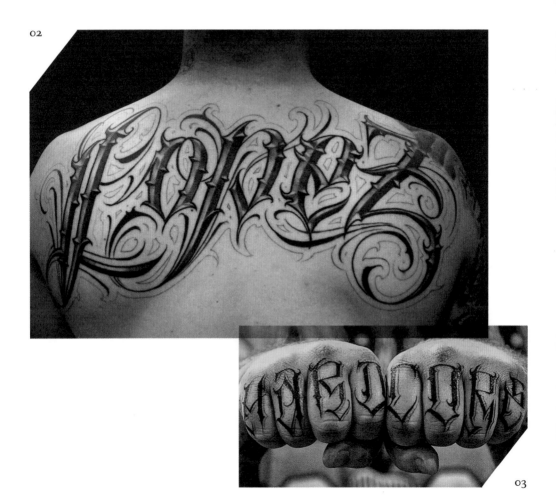

03

01 ~ GREASKULL ~ K.O.
02 ~ LOPEZ ~ K.O.
03 ~ HARDCORE ~ K.O.

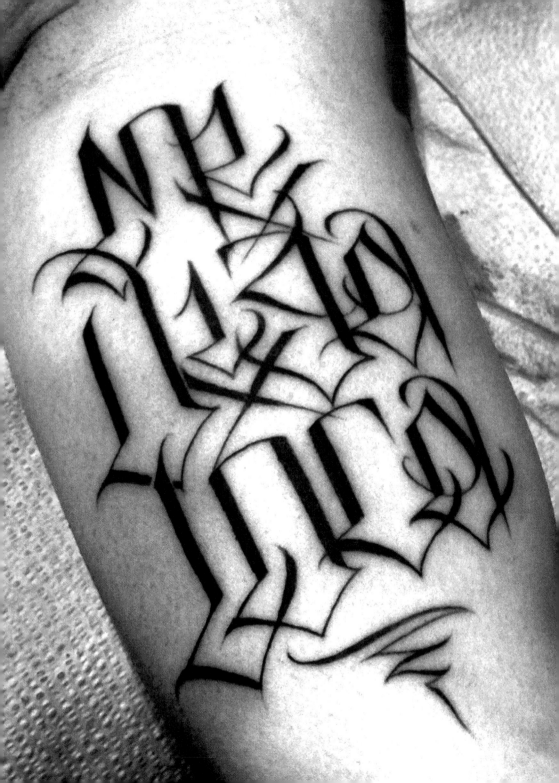

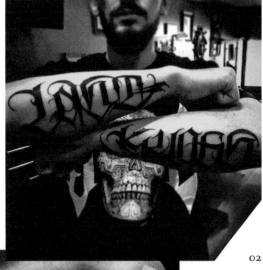

02

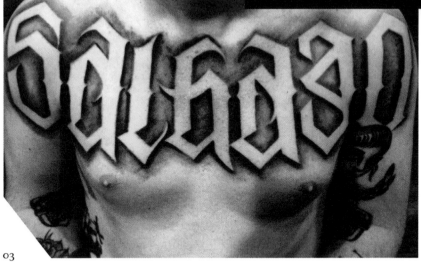

03

01

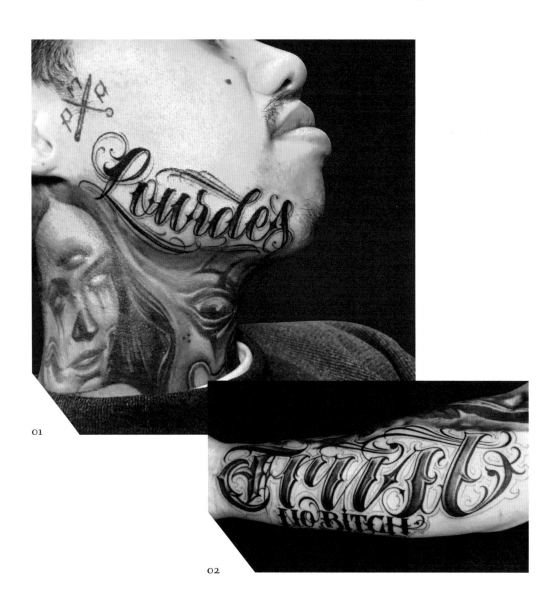

01

02

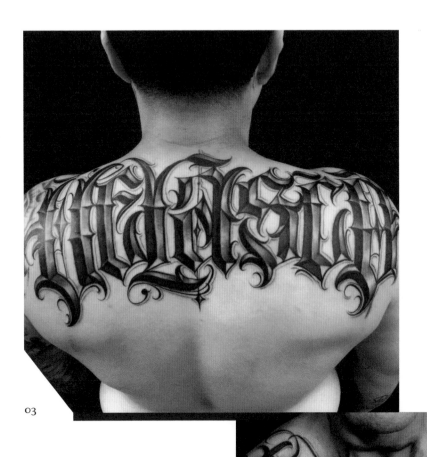

03

04

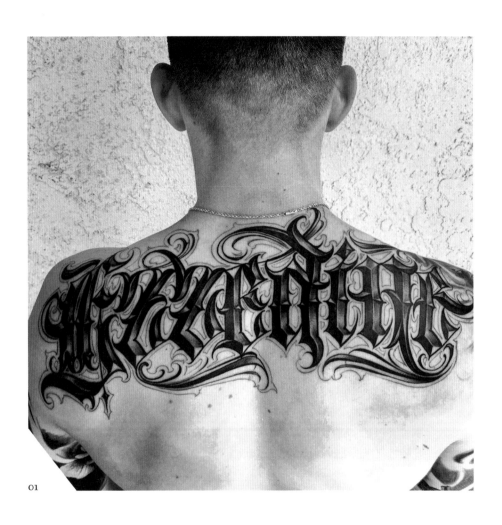

01

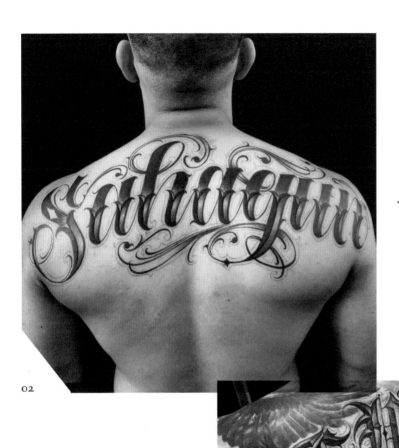

02

03

02

03

01 ~ CALIFAS ~ J.R.
02 ~ I WILL ALWAYS... ~ J.R.
03 ~ MI VIDA LOCA ~ J.R.

01

02

03

01 ~ ANNALISE ~ J.R.
02 ~ GROUPE TUCSON ~ J.R.
03 ~ MY LIFE ~ J.R.

01 02

01 ~ VIVE LA VIDA ~ B.S.
02 ~ FAMILIA ... ~ B.S.
03 ~ FUCK CANCER ~ B.S.

03

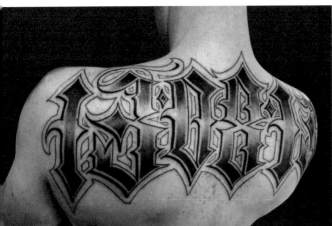

01

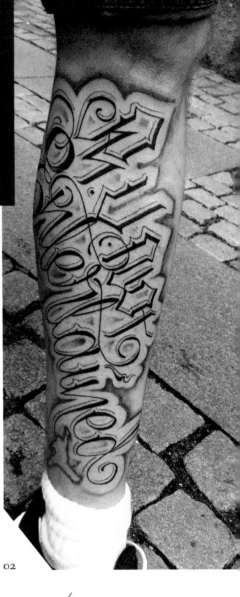

02

01 ~ 130813 ~ B.S.
02 ~ R U NOT... ~ B.S.
03 ~ NO REGRETS ~ B.S.

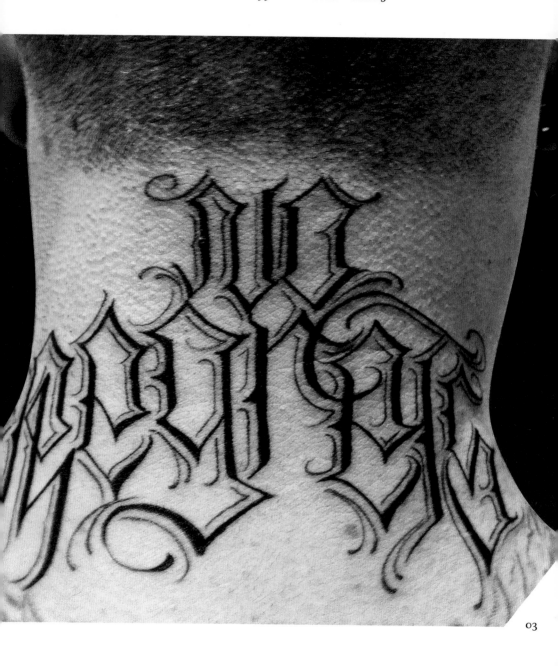

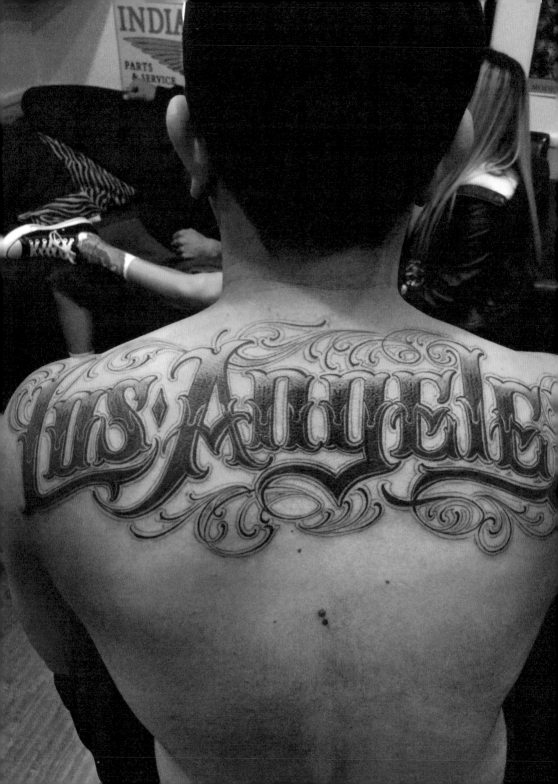

02

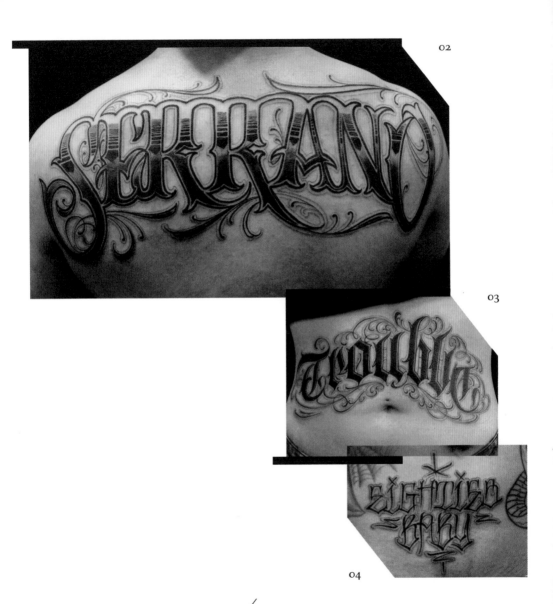

03

04

01

01 ~ LOS ANGELES ~ V.
02 ~ SERRANO ~ V.
03 ~ TROUBLE ~ V.
04 ~ EIGHTIES BABY ~ V.

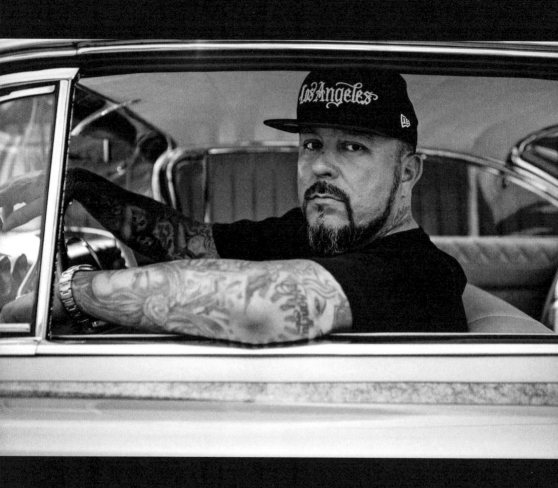

The early 1990s hip-hop era was an important time and the musicians and artists who were really significant in that period had the illest artwork – still done by hand, and telling a real story. LA-based Mister Cartoon was behind much of it.

He is a tour de force in lettering. There is no denying something that's been in demand for decades and is still relevant. That's not a freak accident. That's hard work and dedication. Cartoon has put the hours in when everybody else is sleeping. He's mastered why one particular font works better than other options; he's a virtuoso when it comes to selecting the absolute proper emotion. With all the desktop publishing and font generators hard at work for the newer social media tattoo crowd, his lettering is a luxury item.

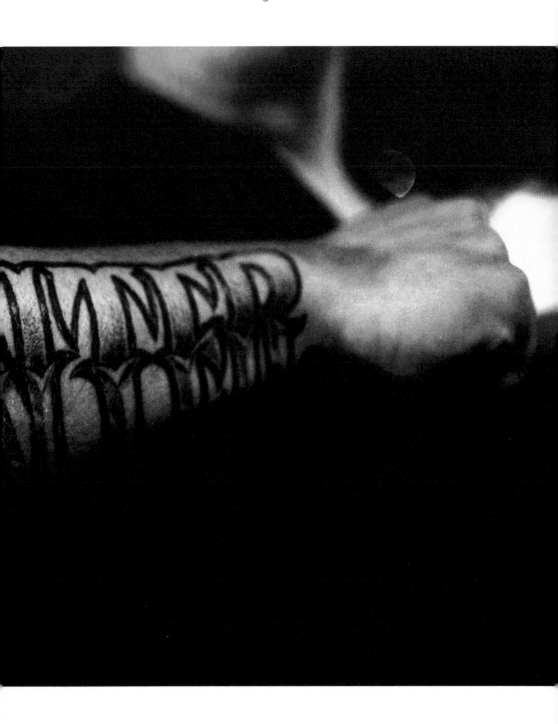

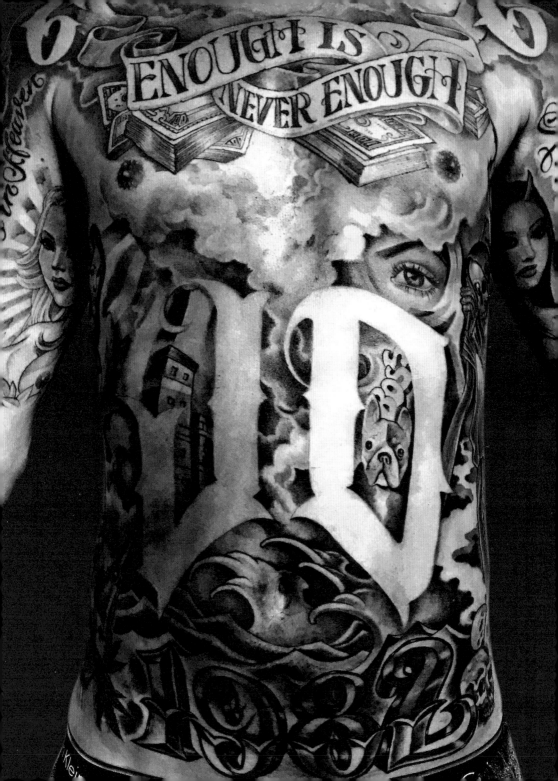

Mister Cartoon's style is one of the world's most recognizable. The iconic flourishes he gives his tattoos are almost like a signature, and not only are these embellishments technically difficult, but it is also critical to know the difference between just enough and way too much. With this decorative element, Cartoon has translated neighbourhood influences via training in traditional sign painting and pin striping to form a style that serves everywhere from the bodies of fellow Angelenos to corporate commissions. No easy task. The rich history of the Chicano culture, filled with emotions that only come from real experience, is integral to every piece of Cartoon's lettering.

BB ~ How did Mister Cartoon happen? How did all this come about?

MC ~ My first professional attempt at tattooing came after getting busted for graffiti when I was seventeen. Detectives pulled me out of class and I had a case against me for destroying the city of San Pedro. I was trying to emulate cats from LA. It was a big thing for us to go up that 110 freeway and get lost in LA. After doing graffiti, people started seeing my name, because I was doing big walls. People started saying, 'that's cool, but can you put that logo on the side of my van' or 'can you put that on the side of a Harley tank' or whatever. So I started getting into airbrushing and I would hang out in the custom shops here in LA, and just try to be around it. This was in the 1980s, so it was very difficult to learn any type of style, but there was one style that I did know how to do, and that was the cholo style, cholo writing, gangster writing,

and everyone from a different area had a different style. In the Harbor Area, we had our own style. In the Harbor Area, there's a lot of bombs [a lowrider slang term for cars of the 1930s and 1940s], and a lot of Harleys that are busted out every weekend, so you start to see a lot of gold leaf, you see a lot of custom stuff and these letters. I remember walking up to this guy that was lettering a VW Bug, and I was like, 'man, I'll be your apprentice, I'll sweep the floors, I'll do whatever', and he was like, 'man, if you want to do that, go to LA Trade Tech'.

So after the summer, I would drive up the 110 and go to LA Trade Tech. A teacher named Mr Hearns ... he was a beast! He was like Archie Bunker, had a mahl stick and told me to leave that fuckin' airbrush at home.

BB ~ Damn, straight old school! How did the school start?

MC ~ The first day of class was lettering: Helvetica, freehand, with a brush, on a piece of brown paper.

BB ~ A lot of people aren't even familiar with a mahl stick.

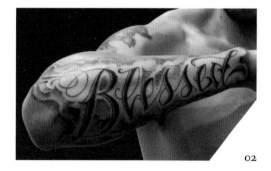

02

01 ~ ENOUGH IS NEVER ENOUGH ~ M.C.
02 ~ BLESSED ~ M.C.

P. 104 ~ HUNTER ~ M.C.

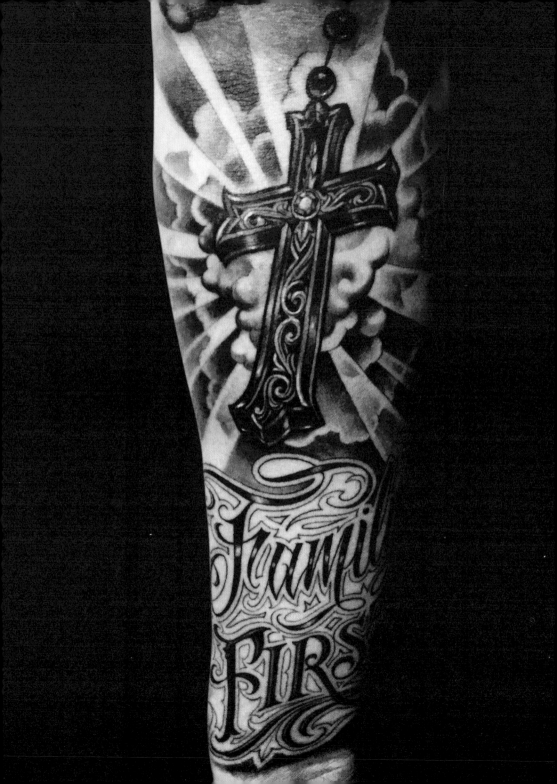

MC ~ The mahl stick is so that you don't put your hands on the surface. You can't touch the surface because it's wet, and One Shot [enamel paint] dries real slow. I thought I was some hot-shot artist, so that shit was really humbling; to realize you're really not that good, and Helvetica is the hardest lettering form to do. Mr Hearns made it look easy. Of course, he had like fifty years' experience on us, but I had never seen it done like that – like flat, and then snapped to get that hard line.

BB ~ I'm sure it was lettering all day, every day…

MC ~ I did enough lettering to realize that I didn't want to compete against guys that had been doing it for so long. They were just far superior, and you could tell there was no substitute for time in that area. Big Daddy Roth came over to me at a convention, put his hand on my shoulder, and said 'watch out for this kid'. So, for me, in my head, I was good enough to leave the lettering world. That was probably around 1990. I ended up befriending these real good pin stripers at school, guys who ended up becoming club members, car club and stuff like that, and with them started to understand weights of letters and balance.

BB ~ Is the school still running?

MC ~ It is probably one of the last traditional sign painting schools, at least on the West Coast. Now, it's just fun to work with those cats. You know, I'll snatch up a couple of the senior

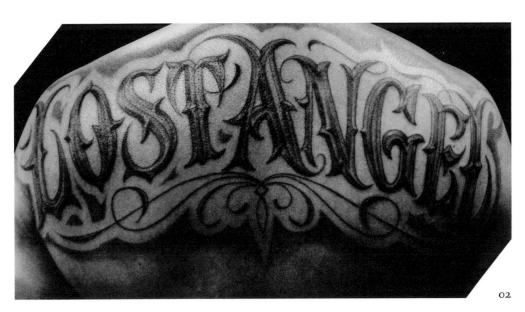

02

01 ~ FAMILY FIRST ~ M.C.
02 ~ LOST ANGEL ~ M.C.

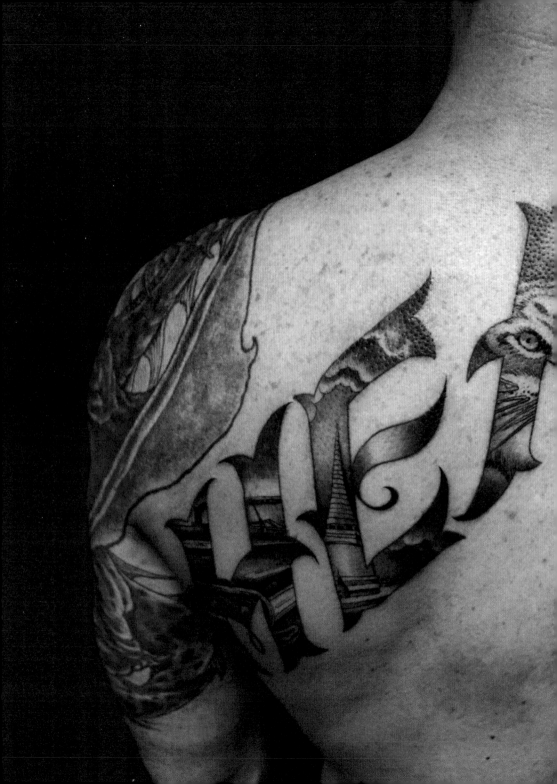

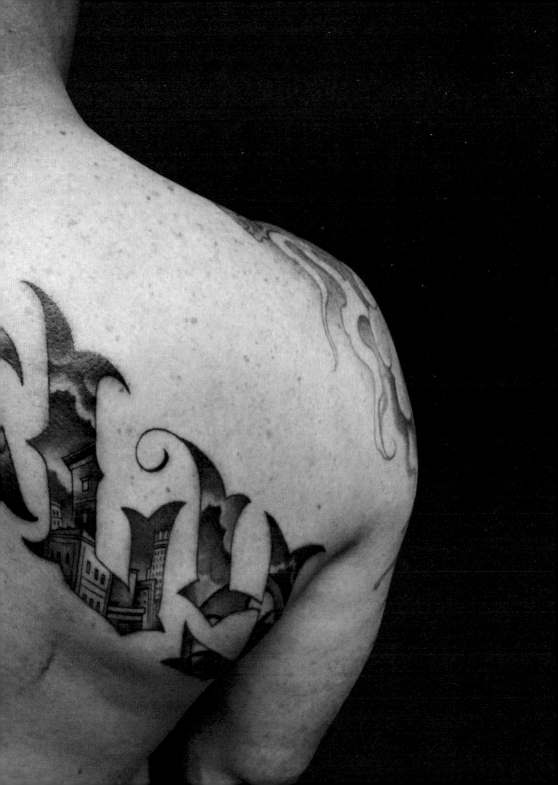

students and get them to work with us on some projects. While there, I started to learn and understand the automotive world, learning how to reduce candy paint, how to reduce urethanes, lacquers, and run them through an airbrush just as if I was painting with a big gun, and I started to do these murals for all the lowriders and hot rods. We would go from hot rod car shows to lowrider car shows, and there's a pretty big leap between them both.

BB ~ It sounds like that was the early foundation for what was leading up to a new street culture that kind of took over?

MC ~ At that time, in the early 1990s, these clothing companies were starting to emerge and we had never had clothing companies before. Out here on the West Coast, we would go to army surplus stores, which were the only places that would sell hoodies or zip-ups and shit like that, big Levi's, and so we kind of created our own style of making clothes too big, and it was a whole movement in Southern California. I was hanging around guys that just started this clothing company called 'X-Large', and my buddy had started a company called 'Third Rail'. I knew that my buddy who started Third Rail was a knucklehead, fighting in the streets and shit, and if he could do it, I could.

My father was a lithographer, started off by sweeping the shop as a kid, and ended up owning a decent-sized shop. I grew up around pallets of white paper. At twelve years old, I was already getting my shit printed, I was doing restaurant menus. I hadn't seen anybody attack those fonts in the apparel industry, so I started doing these little T-shirt companies, these little ones... One was 'Hardcore', one was 'Crazy Life', I had a store and all the fans

that had a 62 Impala, would come in and get the doors all candied up and leafed. This was the early 1990s, way ahead of its time. I was in the apparel business long enough to know that I didn't want to be in the apparel business. Little by little, everywhere I would go I would see people using my letters.

BB ~ Right. So is it like that now in tattooing? Seeing your style 'influencing' other artists?

MC ~ It's not really like tattooing, where it's ok to borrow. We all borrow stuff from each other and we don't sign the bottom of the tattoo, usually, and so it's cool to look at Horiyoshi's stuff and check out his waves and all that. Even though this script writing has been around since the zoot suit days, I'm bringing it to this world, and now all these other people are doing this shit. It motivates me to do some different shit.

I started tattooing, which was one of the hardest things I've done, as far as getting acceptance. I remember tattooers who were plumbers before, and started tattooing, and it was like, 'just follow the stencil! Don't get too fancy'. So my fancy ass was catching all the shit for it. I did an apprenticeship at Spotlight Tattoo and I learned under Baby Ray, so who wants to question that shit?

BB ~ So before Spotlight, were you just tattooing at home? The Harbor Area?

MC ~ Back then we were just experimenting with hand-poked tattoos and making home-made machines that were easy to tattoo with, a light rotary. Then you use a professional machine and that shit is clumsy and wasn't the same. Fools were coming out of the joint with

01

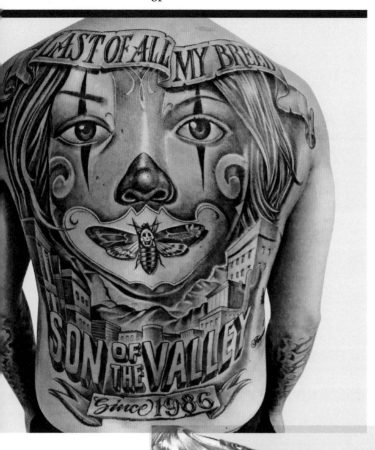

02

01 ~ LAST OF ALL MY BREED ~ M.C.
02 ~ LOYALTY ~ M.C.

P. 110 ~ HEALY ~ M.C.

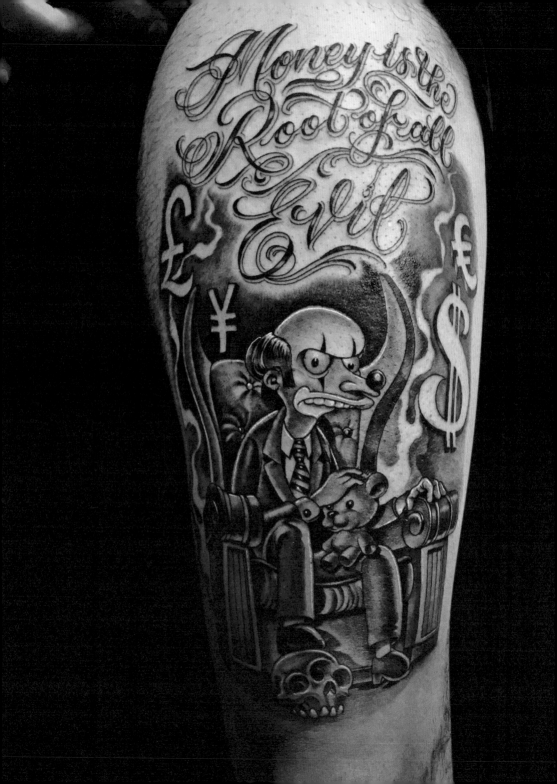

crazy power-shaded portraits, envelopes, and all these designs were so crazy, and in high school I studied all that shit.

Just like how East Coast kids could do a throw-up [a bubble-letter graffiti tag], West Coast kids could do it in script. Or Old English and just bust that shit out. Just some standard hood shit. That was one thing in tattooing I could do that a lot of dudes who were just kind of stuck to a 1970s style of script couldn't. We used to joke about the dudes from the east … like script wasn't their strong point!

BB ~ Ours was more like sailor style, in and out, old school, single stroke, get it done. Like you said, follow the lines, no fancy shit.

MC ~ And that's part of the culture too, man. Like when I first started going to the East Coast, fools were like, 'that's pretty, but I don't want that on me' type of shit. They wanted hard letters. It took time for script to make it.

BB ~ On the outside looking in, that's how it was, man. Going back to your sign painting days, and all the old school influences you had, do you think that you use that now?

MC ~ Oh absolutely. Starting to convex those letters, starting to understand how shadows hit, and then knowing that some of that is not going to look like that. Not to confuse the two parts. Something that will look good with the lines touching on a mirror or some glass, won't translate that great to a tattoo.

At Spotlight, there was a certain way of tattooing in there. My fine line style wasn't really meshing so great, even though Bob Roberts probably did Good Time Charlie's in the 1970s – anything that was kind of photorealism was somewhat frowned upon. I had to make it fit, so I was lining with 3s, lining with 5s, and still doing the homie style, and I had Baby Ray like, 'make that shit bigger, don't be scared!' But the lettering to me was something that was always supposed to be done a certain way. I would've never dreamed of putting lettering on someone's arm. I would always stack that shit, everything is supposed to be from a standing view, nobody ever did that shit.

BB ~ When you first started at Spotlight, was Baby Ray the guy who did the most lettering and fine line style?

MC ~ Ray was a huge inspiration, man. He was the one to tell you how it is. Ray would be like, 'homes, you're doing the script too fuckin' small!' But when you're in the neighbourhood, everything is small, everyone wants these micro portraits of lettering and shit.

BB ~ I see that you draw a lot of your tattoos straight on the skin. Do you prefer that or to use a stencil?

MC ~ I do 90 per cent of my tattoos using a Sharpie. So it's just getting a pen, going and taking flight. If it's something super-precise, like a portrait or something, I'll use a stencil.

BB ~ You were at Spotlight until when?

MC ~ 1999.

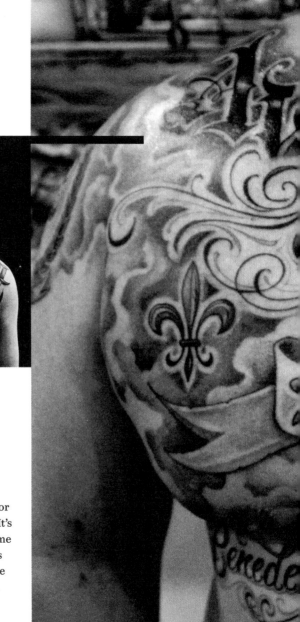

01

BB ~ During that time, did you see any lettering trends? More collar rockers or stomach rockers?

MC ~ For sure. It went crazy. But, the collar was reserved for oldie song lyrics. It wasn't supposed to say 'my dreams are in my mind' or whatever shit they come up with these days. It's supposed to say 'drifting on a memory' or some old Motown song shit. The stomach rocker is your last name or your neighbourhood. Same thing for the back. That's it. But it's changed now, man. Those same rules don't apply.

01 ~ RAMIREZ ~ M.C.
02 ~ VARIOUS ~ M.C.

02

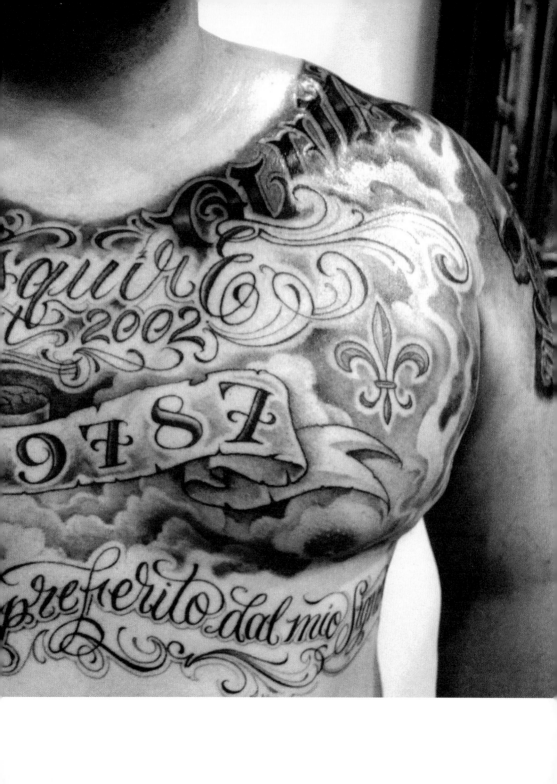

INTRODUCTION

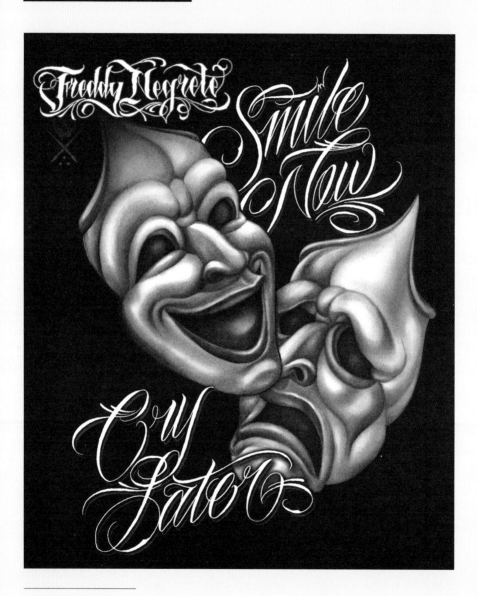

One of Freddy Negrete's great contributions to tattooing is the 'Smile Now, Cry Later' design. Here is an example in his hand.

Tattoo lettering forms develop through evolution. The script style, as it is currently manipulated, is no exception. With the fine line, Angeleno approach as antecedent, contemporary script tattoos privilege flowing form, often augmented by decorative filigree, to honour names or relay whimsical statements ('love', 'hope', 'believe', 'good times' and so on).

The script style's connection to emotive, but not necessarily grounded, statement also has origins within the early development stages of the West Coast style. Whereas Old English fonts were used to designate family names or neighbourhoods, script was often employed when writing sentimental or nostalgic phrases, typically drawn from song titles. These became necklace or collar tattoos, each designed to illuminate the life of the wearer.

Among the songs that gained popularity for their tattooed phrases are James Brown's 1958 'Try Me' (from the album *Please Please Please*), Bloodstone's 1973 single 'Natural High', Heat's 1977 hit 'Always and Forever', War's 1971 track 'Slippin' into Darkness' and, most famously, Sunny and the Sunliners' 1966 'Smile Now, Cry Later'. If not the most prevalent in number, these are representative of the doo-wop, harmony and rhythm-and-blues soundtrack that fuelled early Chicano lowrider culture. As the beat of the community, the lyrics transcended the music and became part of the local vernacular.

Like the drippy, angular Old English font now synonymous with the West Coast style, script lettering in tattooing owes a lot to the legacy of Jack Rudy, Freddy Negrete, and Good Time Charlie's Tattooland. Negrete, for one, standardized a 'Smile now, cry later' design, placing his spin on script into widely disseminated flash (tattoo design) sheets. As fine line, or black and grey, tattooing blossomed from a regional to an international style in the 1990s and early 2000s, script lettering in delicate, tight line form also became more and more commonplace.

Once it was more common, as with all other lettering forms employed in tattooing, deviations on the standard script emerged. Much of this is predicated first and foremost on line weight – single, double, triple, and so on – but it is also relayed as varying degrees of embellishment. The output of such artists as Em Scott (who is interviewed in this section), Rudy and El Whyner is evidence of how the basic backbone of script can be manipulated (varying size, flourish and more) to fill space on the body or in a banner. The decisions about embellishment are critical to the end success – the combination of shape, tone and legibility.

Ultimately, script tattoos range from basic linked cursive through the fancy (a few curlicue exaggerations added) to the fantastical (when the auxiliary lines spreading from the letter form a border of adornment), and as with all lettering choices the end graphic statement should fit with the sentiment of the word chosen.

HOW TO GUIDE

When starting out with script, don't forget that there is nothing wrong with tracing. Find yourself some good references and get to it. This practice builds up your muscle memory and allows you to start to figure out the structure of the letters you're writing, which is crucial to success.

- Always start a script letter drawing with some guidelines. These could be straight or slightly curved. I honestly prefer slightly S-curved, as this position gives the word(s) a little extra flavour and visual appeal.

(Tattoo)

- With multiple lines, a problem can arise if you try to make the lines of script too close together, not taking into account letters with descenders, or tails, such as Y or G or P, which dip below the guidelines and essentially get in the way of the other letters.

(As a general rule …)

- To combat that problem, I'll usually write out each line of lettering separately, and then start assembling it, adjusting the letters as I'm doing the work.

(aer)

- You see that the G in 'general' (above) dips low and into the 'should': that's where you can make the adjustment. Redraw the G and make it flow into the word below it or use it as part of one of the letters.

(ith, ish, ism)

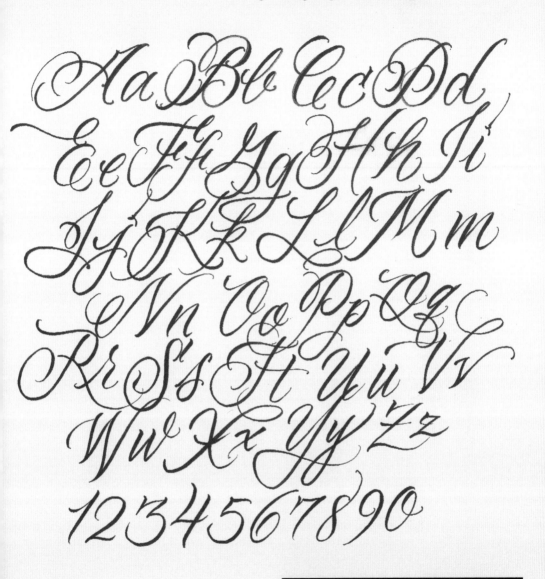

- I can't stress enough the importance of consistency. If you add a flourish to one letter, add it to the other ones as well. For example, see the beginning or back left side of the B, D, R and T.

- Keeping all the letters at the same angle is important. A natural handwriting angle is always pleasing to the eye; however, you can use a more upright approach and still have success – just make sure all the letters are done that way.

Gracious

hand made

Thank You!

Style & Grace

Please

Be Nice!

Manners!

Examples of fancy script
tattoo lettering in common
names and phrases.

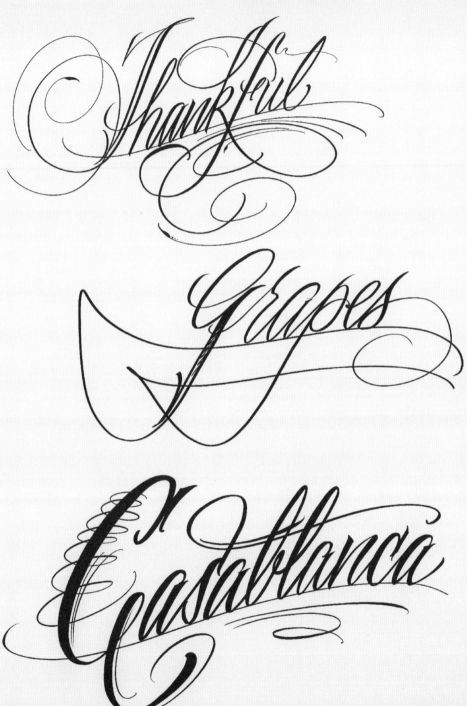

Muerte

Vida

Mi

Corazon

Nunca

Siempre

Vive
Rie
Amor

Amor Mio

Examples of fancy script tattoo lettering in common names and phrases.

Paris

London

Tokyo

Los Angeles

Brooklyn

Miami

Mother

Father

Sister

Brother

Examples of fancy script
tattoo lettering in common
names and phrases.

Smooth Operator

In Loving Memory

Gone But not Forgotten

GALLERY

Brigante
Elvia Guadian
Huero
Henry Lewis
El Whyner
Vetoe

Interview:
Em Scott

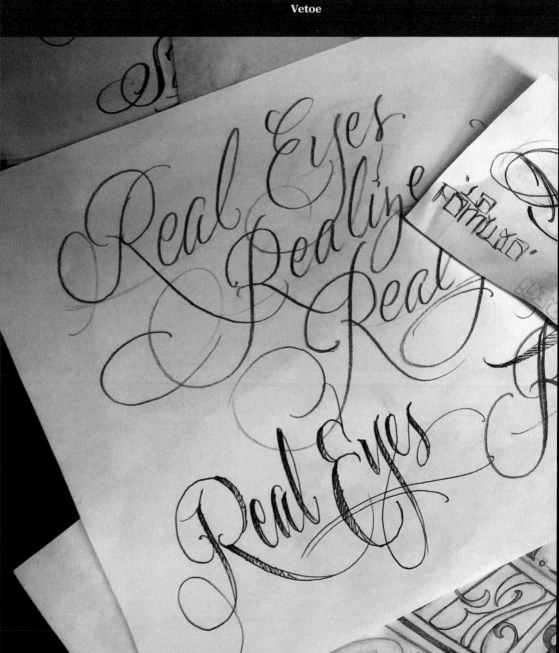

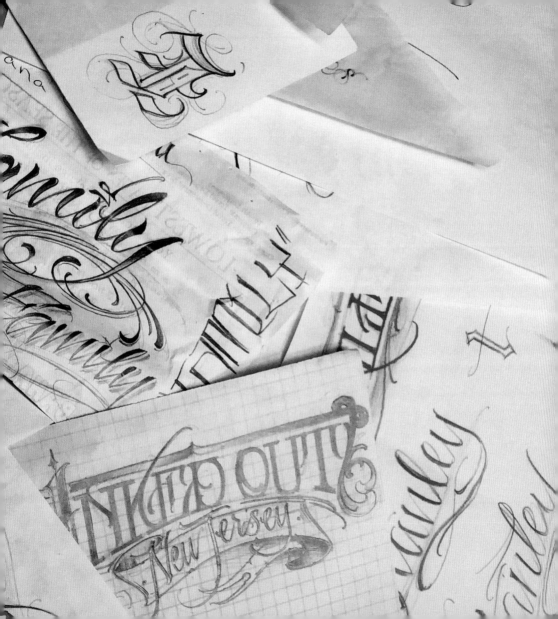

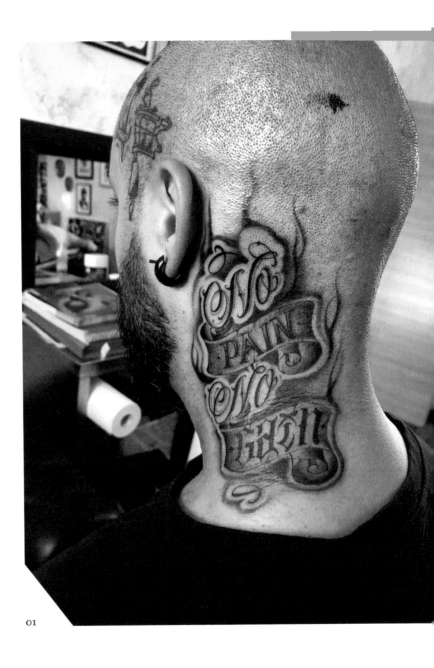

01

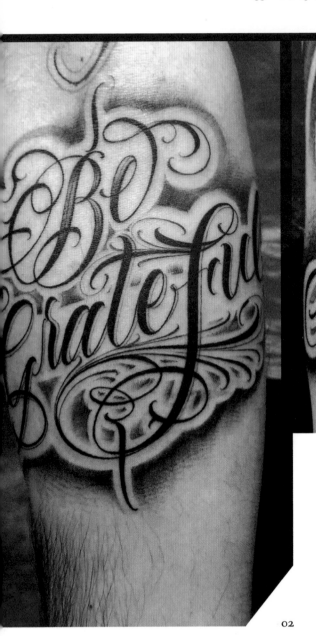

03

02

01 ~ NO PAIN, NO GAIN ~ B.
02 ~ BE GRATEFUL ~ B.
03 ~ MOM ~ B.

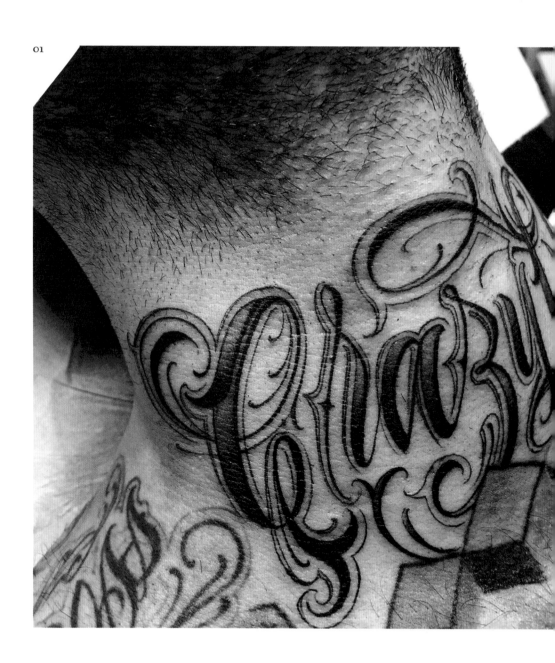

02

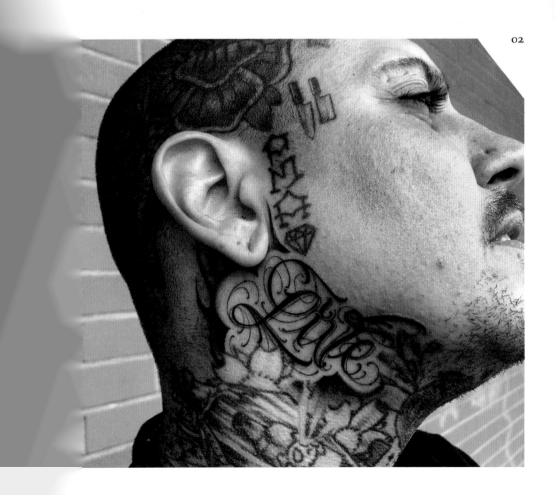

01 ~ **CRAZY LIFE ~ B.**
02 ~ **LIVE ~ B.**

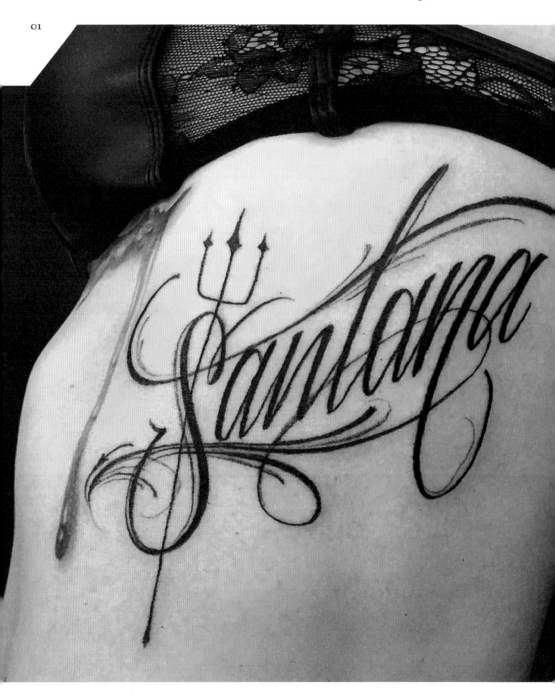

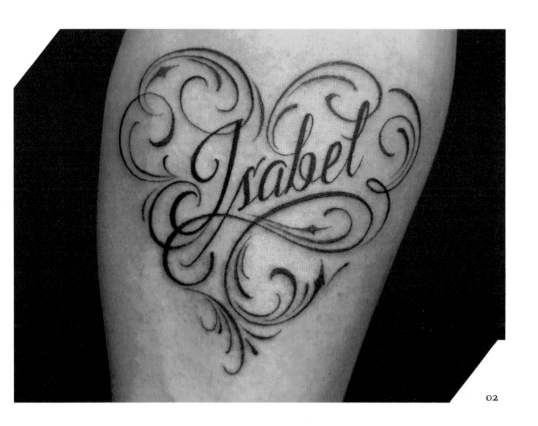

02

01 ~ SANTANA ~ E.G.
02 ~ ISABEL ~ E.G.

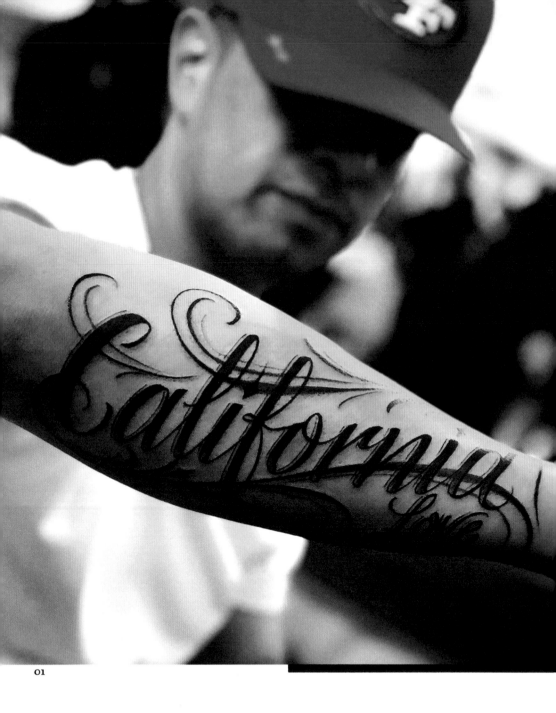

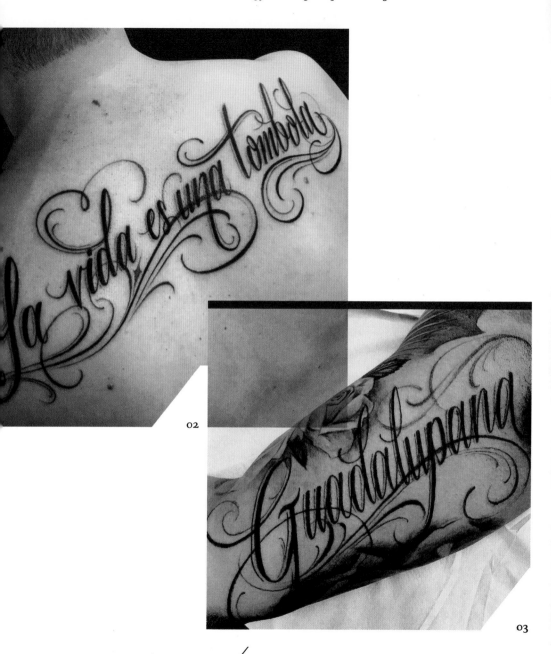

02

03

01 ~ CALIFORNIA ~ E.G.
02 ~ LA VIDA ES UNA TOMBOLA ~ E.G.
03 ~ GUADALUPANA ~ E.G.

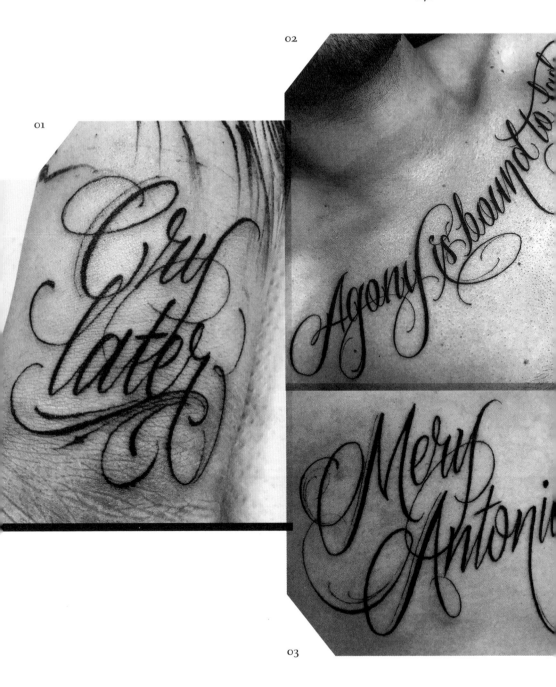

01

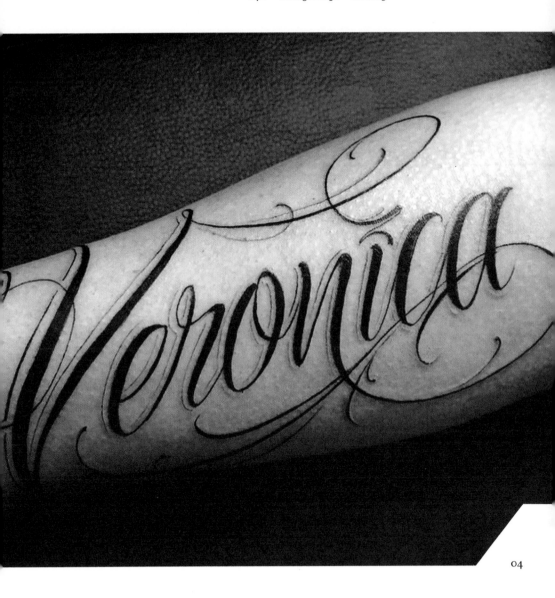

04

01

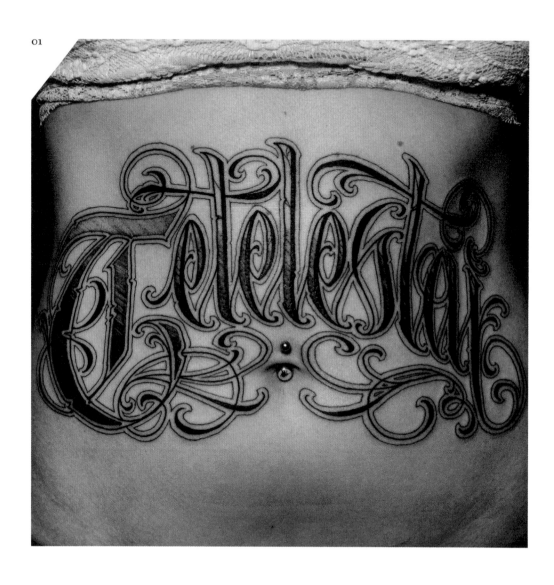

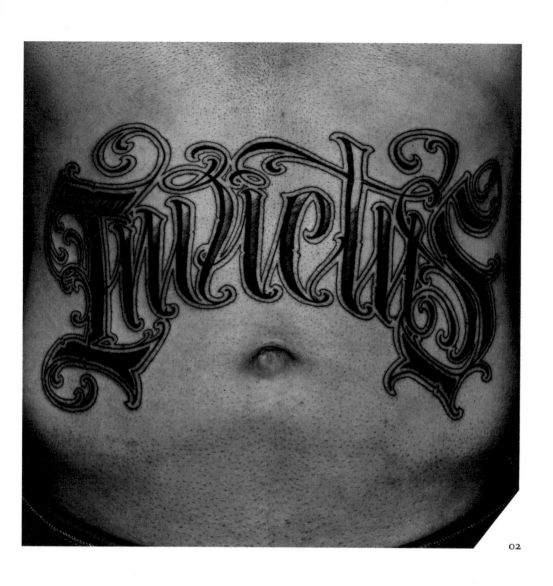

02

01 ~ TETELESTAI ~ H.
02 ~ INVICTUS ~ H.

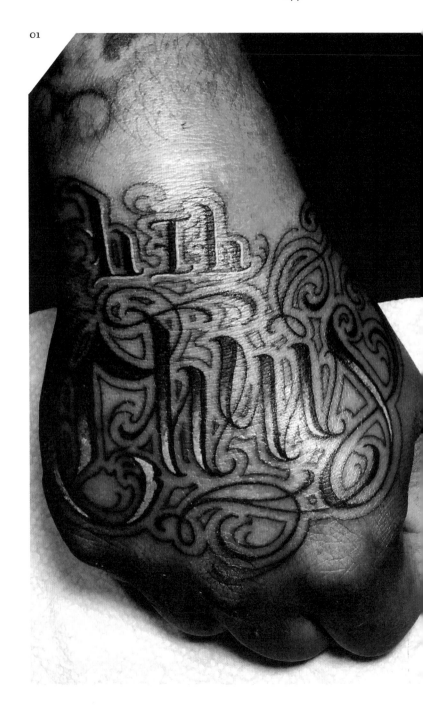

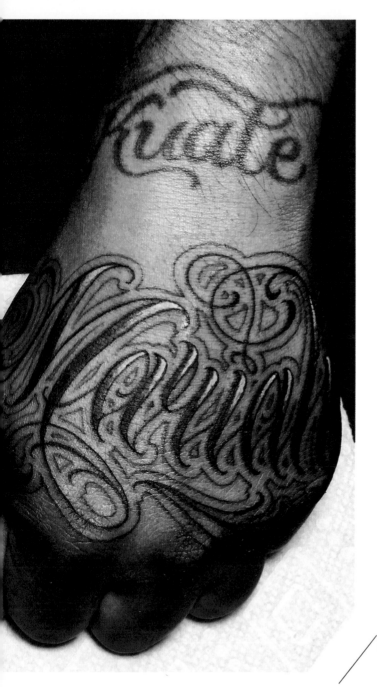

01 ~ CHRIS, MARIAH ~ H.

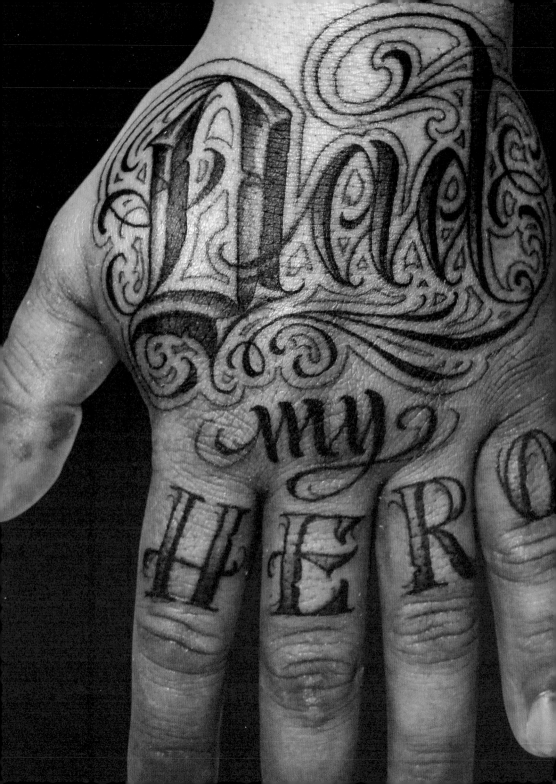

01

01 ~ DAD MY HERO ~ H.
02 ~ DEVINA ~ H.

01

03

02

01 ~ DOOM & GLOOM ~ H.L.
02 ~ WILLING ~ H.L.
03 ~ ARE YOU NOT ENTERTAINED ~ H.L.

01

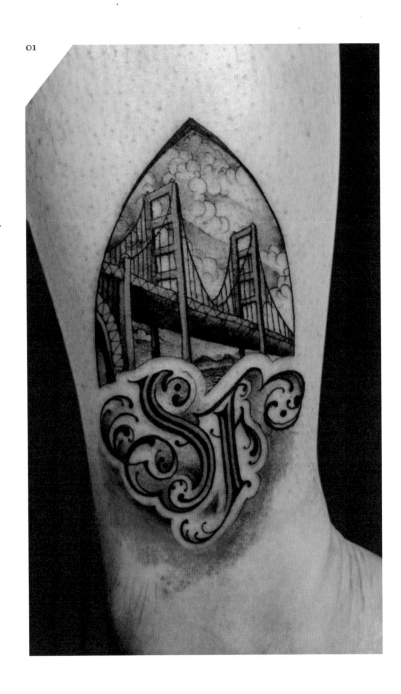

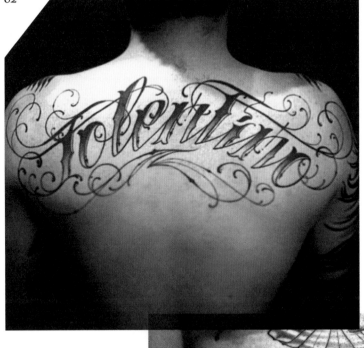

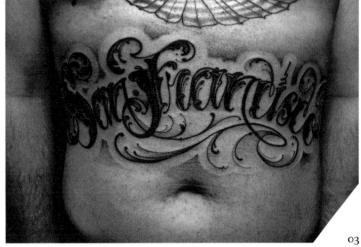

03

01 ~ SF ~ H.L.
02 ~ TOLENTINO ~ H.L.
03 ~ SAN FRANCISCO ~ H.L.

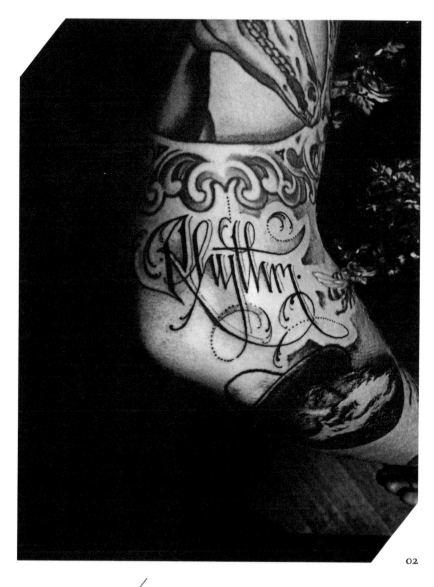

02

01 ~ NIXON ~ H.L.
02 ~ RHYTHM ~ H.L.

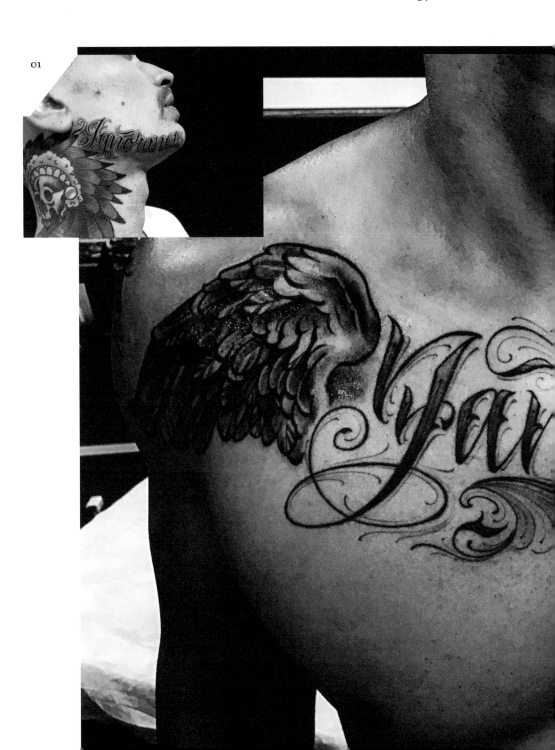

01

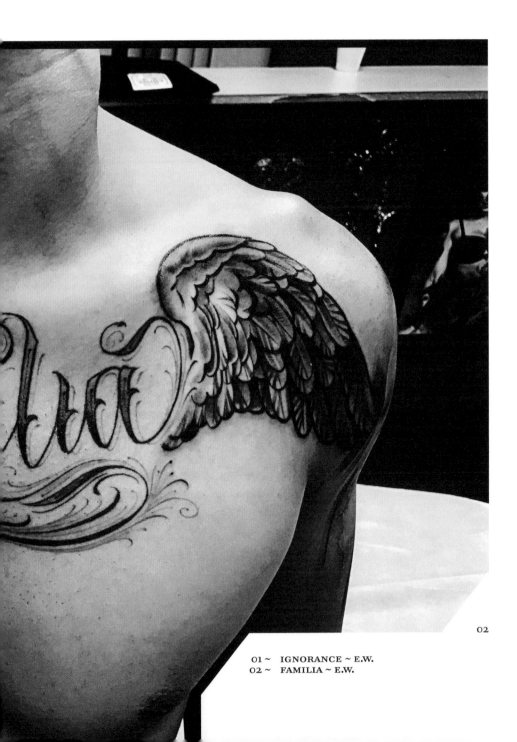

02

01 ~ IGNORANCE ~ E.W.
02 ~ FAMILIA ~ E.W.

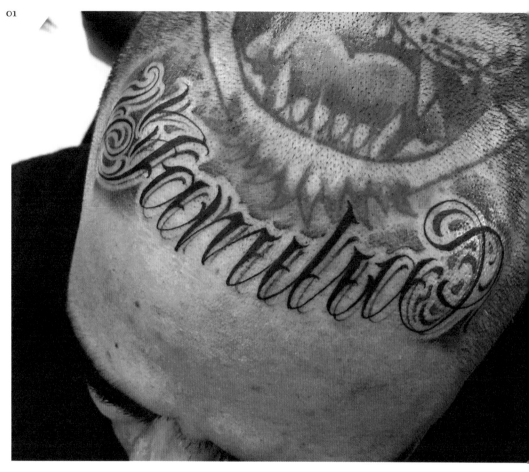

03

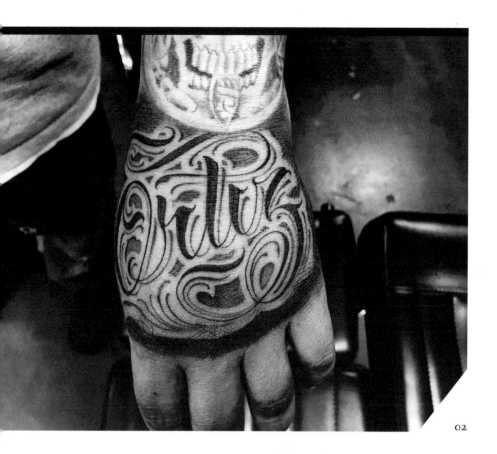

02

01

01 ~ STAY HUSTLIN' ~E.W.
02 ~ ORTIZ ~ E.W.

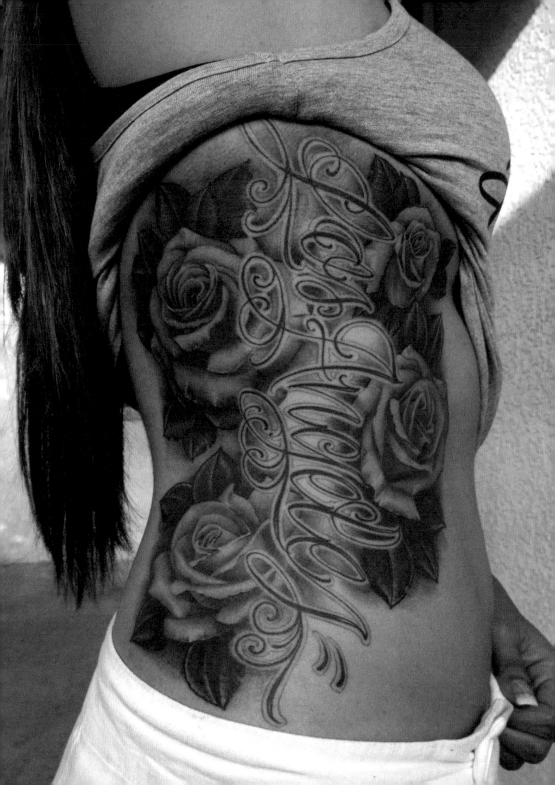

02

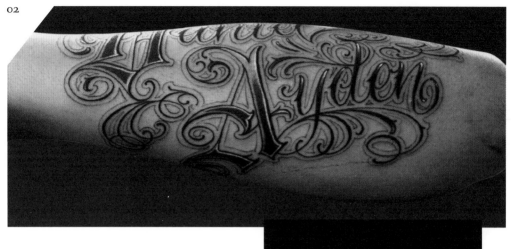

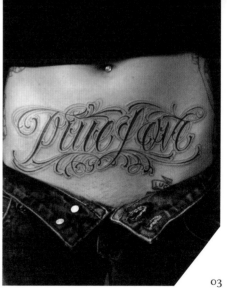

03

01

01 ~ **LOS ANGELES ~ V.**
02 ~ **DANIEL AYDEN V.**
03 ~ **PURE LOVE ~ V.**

INTERVIEW

Em Scott

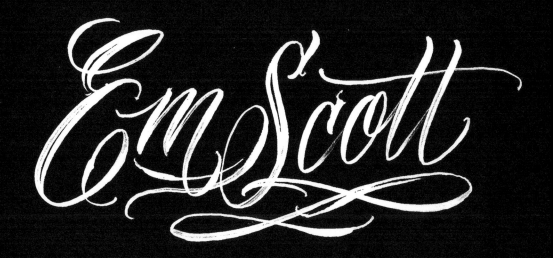

For Em Scott, script tattoos require three key components: alignment, balance and flow. The latter refers to how the letters sit on the body, while the other two characteristics define how the flourishes – the curlicues and filigree – accent but never overwhelm the legibility.

Scott was born in Los Angeles and was naturally drawn to fine line, black and grey tattooing. She credits her interest in tight detailing to the influence of her grandfather, a painter of realistic oils, and notes that she began practising lettering years before she learned to tattoo. Her style is defined by delicate, clean lines and clarity of purpose.

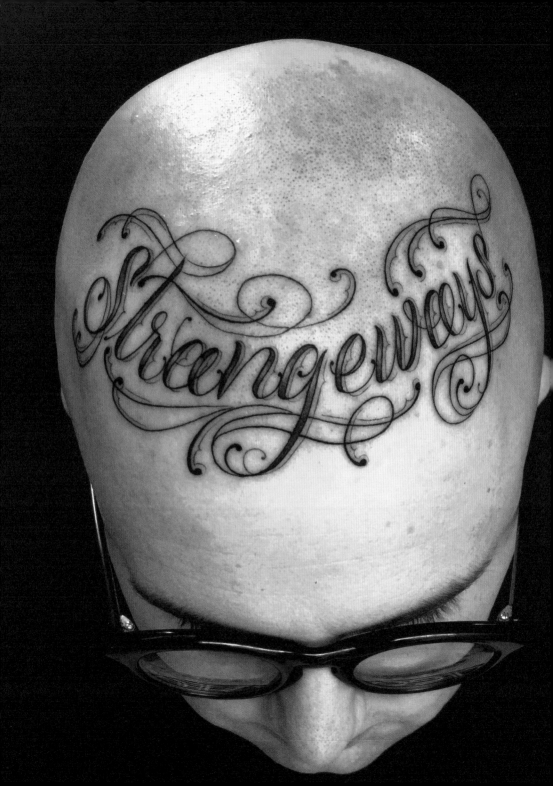

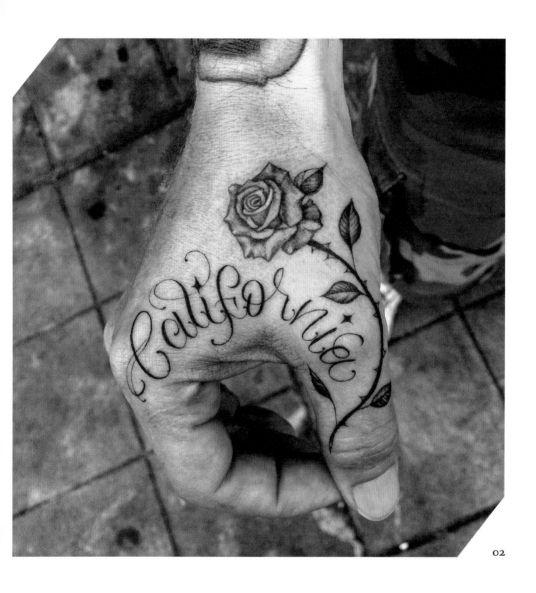

02

01 ~ STRANGEWAYS ~ E.S.
02 ~ CALIFORNIA ~ E.S.

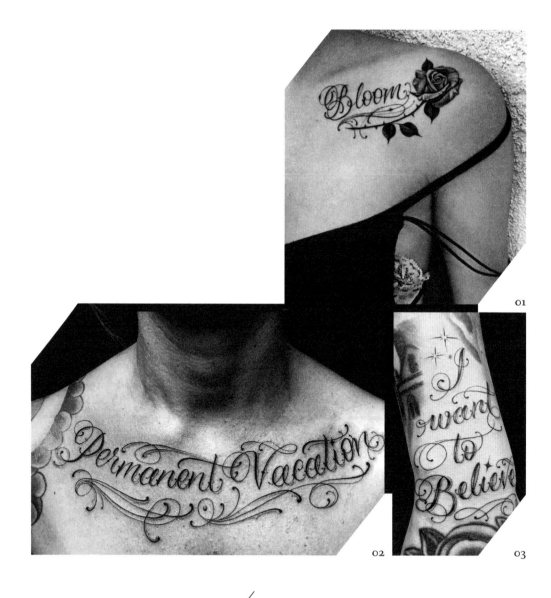

01 ~ BLOOM ~ E.S.
02 ~ PERMANENT VACATION ~ E.S.
03 ~ I WANT TO BELIEVE ~ E.S.

01

02

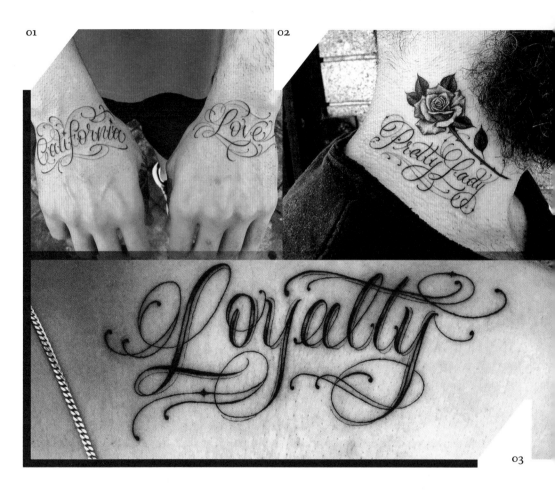

03

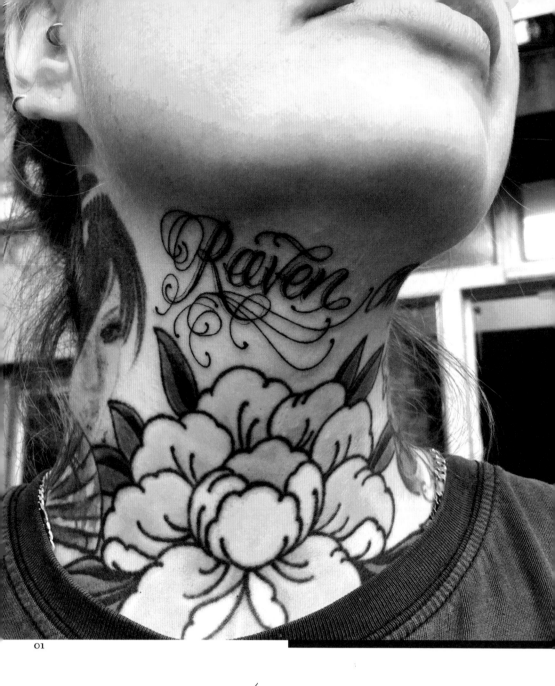

01 ~ RAVEN ~ E.S.
02 ~ HELLO STRANGER ~ E.S.

BB ~ What elements do you take into consideration when you're approaching a tattoo?

ES ~ Well, first, I guess it depends on where it's going on the body, and most of the time I don't draw it on a straight, horizontal guideline. I like to give it some shape, and use an 'S curve' type of guideline. I try to space the letters evenly, and generally I can eyeball it pretty good. I definitely take into consideration the word or phrase I'm doing and think about what font would best describe that word or name or whatever I'm doing.

I'll also ask the customer if there's any style they like or anything they've seen that they're leaning towards, and that definitely helps in my design approach. Sometimes they just tell me to do whatever I want, but that's not as easy as it sounds. I'll consider if the customer is male or female, which will help me decide on whether the lettering has heavier lines or is more fine line and dainty, unless it's requested to be that way.

BB ~ Cool, yeah, and make adjustments as you're drawing…

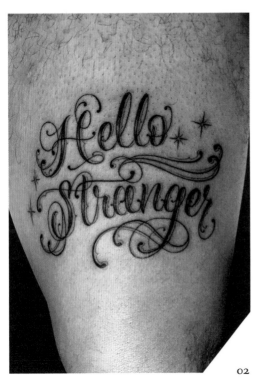

02

ES ~ Yeah, for sure. I think the line weight is pretty important as well because that's also going to tell the story and make it believable. Some letters just look the best with that thick and thin look, and some, they just need that heavier, bold line.

BB ~ Do you like to draw lettering directly on the skin or prepare a drawing first?

ES ~ I prefer to draw stuff right on the skin unless it's something super-small and I'm afraid of losing the stencil, but most of the time I prefer to draw the lettering on the skin. I think it fits better that way.

BB ~ How do you approach adding lettering to an existing tattoo?

ES ~ Well, I take all their existing tattoos into consideration. I think a lot of the new tattooers don't really give this much thought and just slap it on there and go for it. I try and make everything flow as much as possible and fit the best, and let's say I'm adding some lettering to a portrait, I try and make the lettering go with the portrait. Usually, with a portrait, that would be script, but it doesn't have to be. If I'm adding some lettering to another existing tattoo, I just try and give it the best font for the image and think about if they got this all together the first time, what would be the best choice.

BB ~ Exactly how I do it.

ES ~ Also, you know, adding the flourishes and all the extra stuff is an art all in itself.

BB ~ A hundred per cent it is. Do you approach that the same way?

01

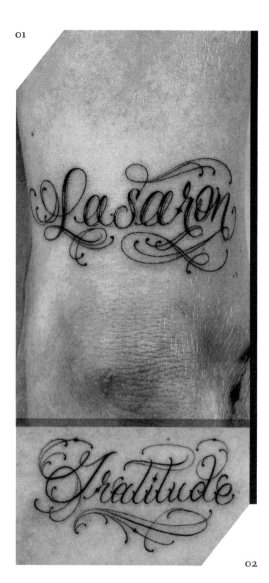

02

01 ~ LASARON ~ E.S.
02 ~ GRATITUDE ~ E.S.
03 ~ EMILY HOLLOWAY SMITH ~ E.S.

03

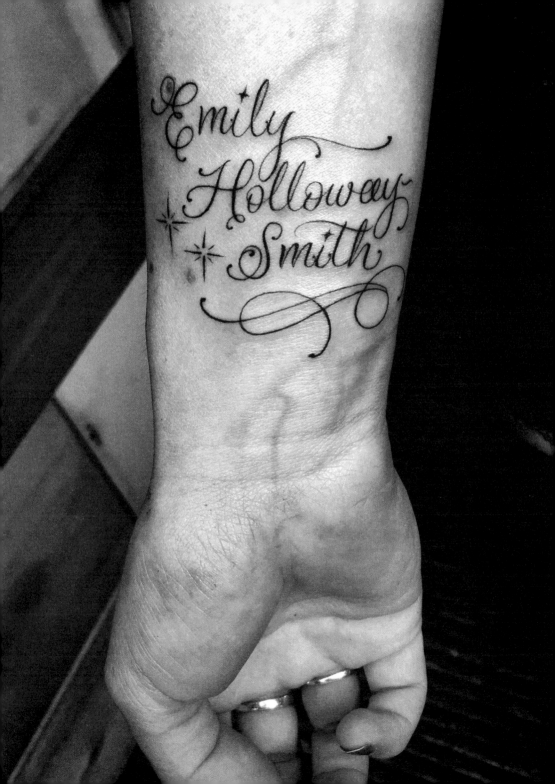

And until we
meet again, may
God hold you
in the palm of
his hands

02

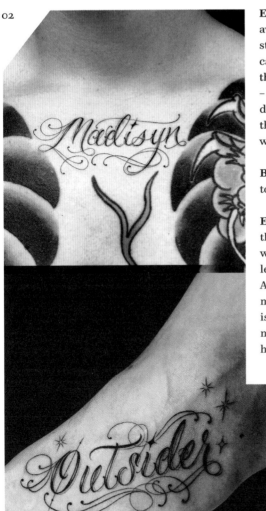

ES ~ Yes. Well, I guess I look at the space that's available after I draw the main part, then I'll start sketching the flourishes to fit. I'm very careful that I don't overdo it with that part of the tattoo because it starts to look ridiculous – like the artist didn't know what they were doing and just started adding more and more thinking that they're really 'hooking it up' when it has the opposite effect.

BB ~ What are some general rules that apply to doing a nice script tattoo?

ES ~ First, for me, is legibility. I've seen tattoos that I think are beautiful, but it takes me a while to figure out what they say and what letter is what. It almost confuses me a little? Also, keeping everything on the same angle. No matter what angle that is. Whether everything is on a slant, or more of an upright style, just make sure it's consistent. Those things also help with legibility.

03

01

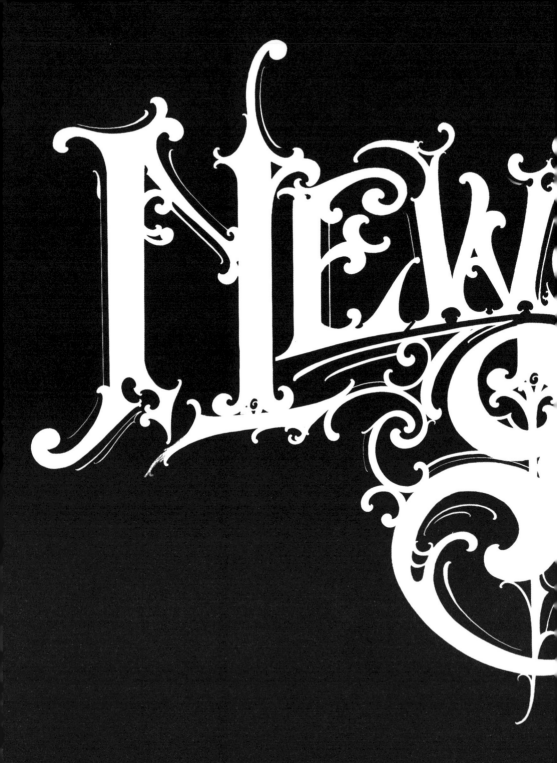

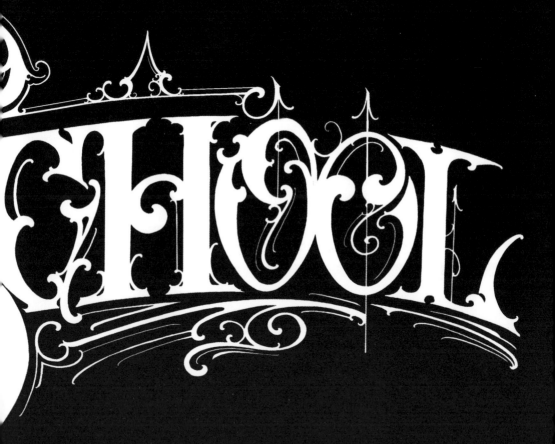

INTRODUCTION

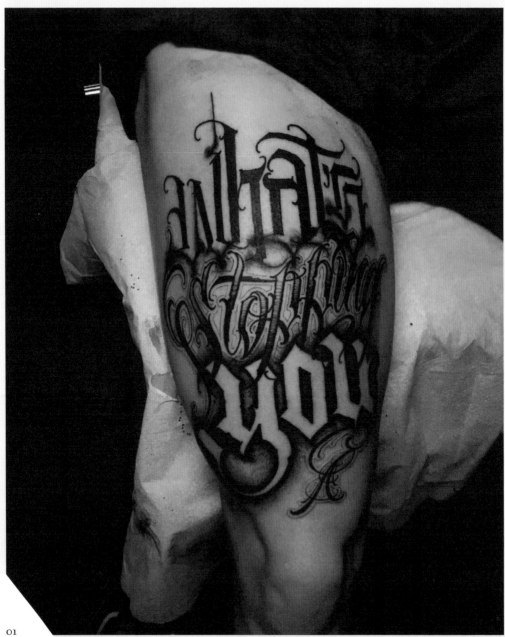

While traditional, West Coast and script letter tattoos form a clear historical continuity, the styles that took root after the turn of the 21st century are indicative of a shift within tattooing. In it rules are not, per se, eschewed, but the impetus to bend, stretch and test the limits of tattoo dogma helps realize new opportunities for form.

As these expressions are not split so cleanly into factions, the nebulous umbrella of 'New School' serves. The implication here is also a reminder: New School is not singular. It is instead the manifestation of a moment in tattoo history when practitioners of a broader spectrum of art practice (from traditional graphic design training to graffiti) open up a wider aperture of reference points.

Although there are ideas, including the neo-Victorian aesthetic driven by Noah Moore (interviewed by B.J. Betts within these pages), that permeate across the industry, New School is defined by its range of articulation – particularly in what has become popular in the last decade. Within it you find an approach that simultaneously advances the scope of letterform but also treats the word as an opportunity to fashion a full composition. For example, one type of New School lettering (an advance of the West Coast style) manipulates the negative space of intense shading to craft the letters. In other instances, the interior of the letter becomes a vehicle for ornament – sometimes filigree – or even pictorial scenes.

One can see this in the work of Buster Duque, who expertly utilizes outline to augment structure and add volume. Similarly, Sam Taylor deftly blends historical influences in his letter compositions. Within them, decorative elements from gothic typefaces are embellished with ornamental filigree and a brilliant interplay of heavy and light shading to form dynamic, large-scale word-led designs. In contrast, Delia Vico will often mix fonts in a single tattoo without shifting line weight.

These variances, and the emphasis on organic shapes, make New School lettering adaptable to a variety of uses. It allows for the infill of an awkward space and also presents opportunity for substantial coverage (as seen in Duque's and Taylor's work) via a creative distortion of the letter, both horizontally and vertically, and its surroundings. Whereas lettering was once confined to distinct parts of the body – stomach, collar, upper back, forearm – with New School, words and phrases have become the basis for back pieces, full legs and sleeves. The latter point is important, because New School letterforms consider auxiliary line as integral to the character of a chosen font – a way to amplify a word or phrase, never to muddy legibility.

HOW TO GUIDE

Work in this style when you want to go big and make an impact. The beauty of it is the combination of embellishment from traditional sign painting with a rule breaking derived from mentality. Think critically about both space and parallel lines and you'll succeed in making even the tamest word or phrase feel monumental.

- Once again, starting with a rough sketch is always critical for a good design.

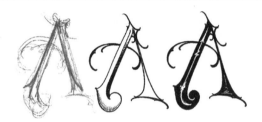

(AAA)

- Often, unfortunately, people try to make two differing fonts work together by force, and that is usually unsuccessful. Two fonts of a similar style will generally work a lot better.

(Have Fun)

- The shapes of the letters themselves are very important to the overall feel of the word or phrase. Be sure to utilize the entire space that is available.

(Love)

- It's important to take advantage of the visual parallels with this font.

(Letters)

- This is a very ornate font, and has a strong sign painter and Victorian influence.
- Unlike a more basic font, this style of lettering is better viewed on a larger scale so that the detail can be properly utilized and best appreciated.

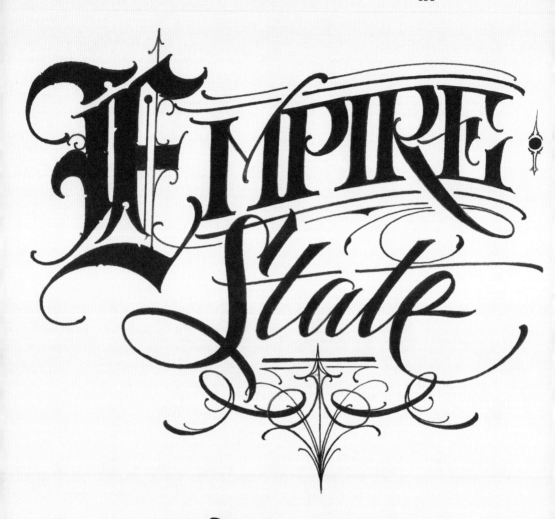

*Examples of New School
lettering in popular phrases.*

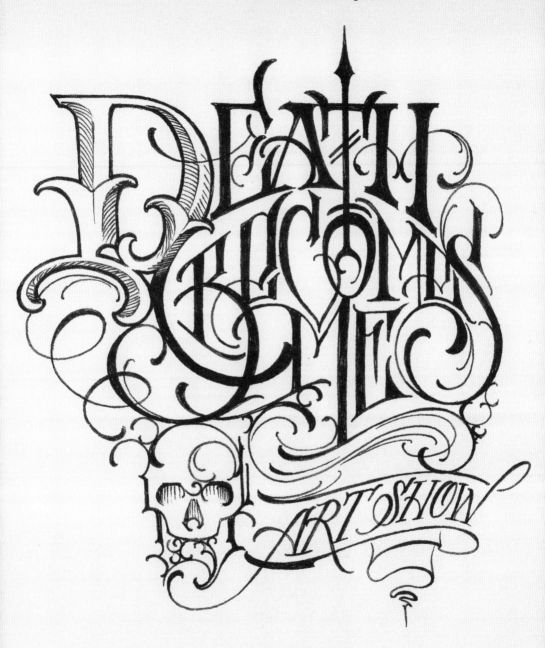

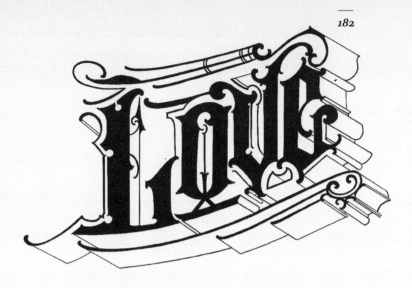

Examples of New School
lettering in popular words
and phrases.

STACKS

Made FOR Makers

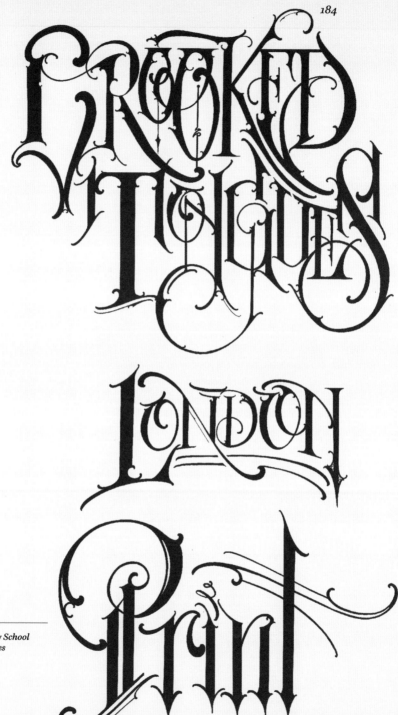

Examples of New School lettering in names and places.

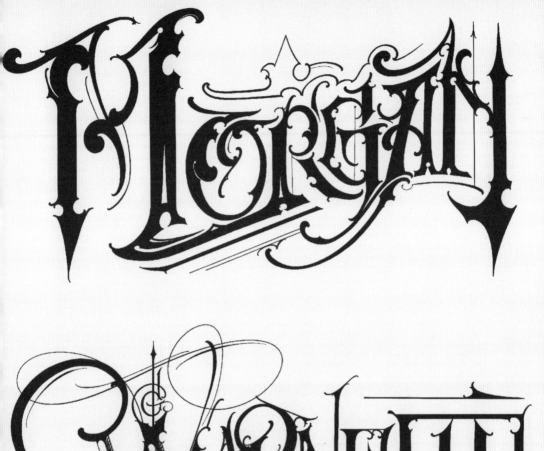

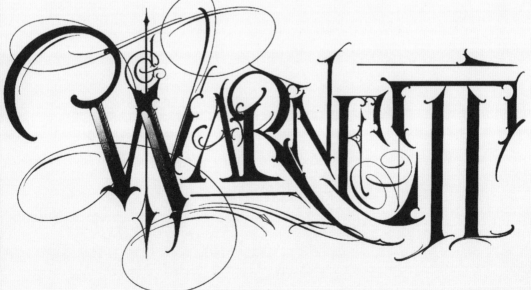

GALLERY

Big Meas
Sam Taylor
Kailey Vamp

Interview:
Noah Moore

—
186

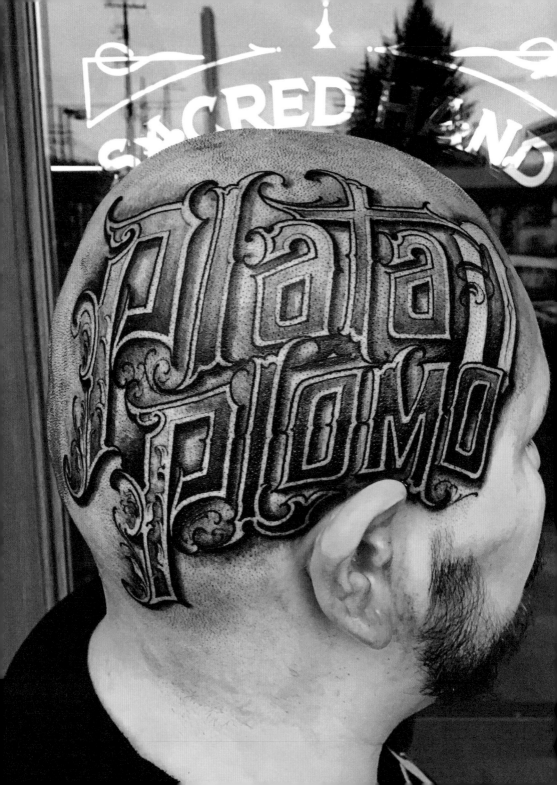

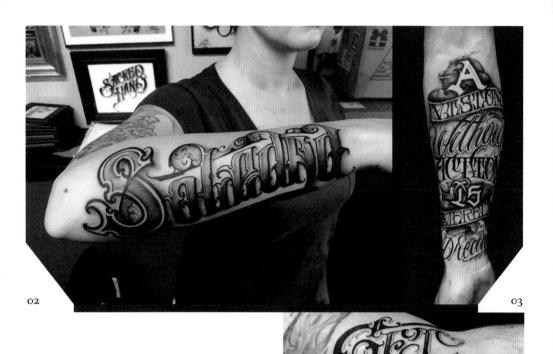

02

03

04

01

01 ~ PLATA O PLOMO ~ B.M.
02 ~ SOLEDAD ~ B.M.
03 ~ A VISION WITHOUT ACTION... ~ B.M.
04 ~ GET SERIOUS ~ B.M.

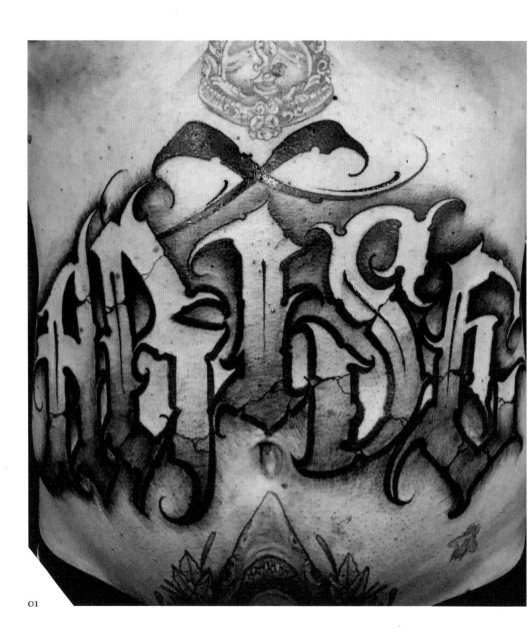

01

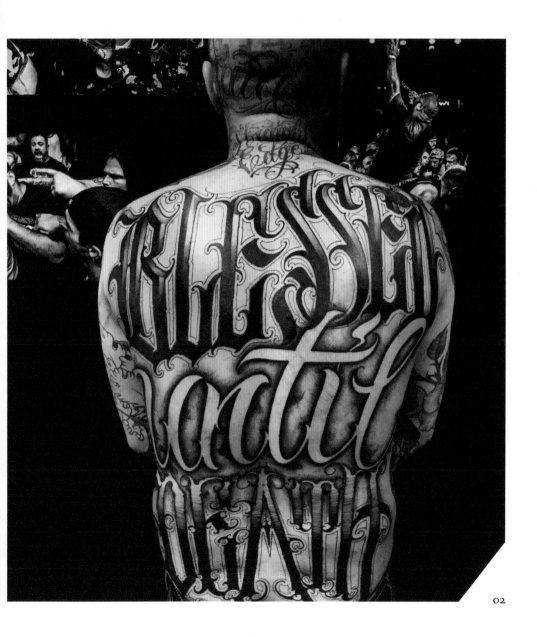

02

01 ~ ARISE ~ B.M.
02 ~ BLESSED UNTIL DEATH ~ B.M.

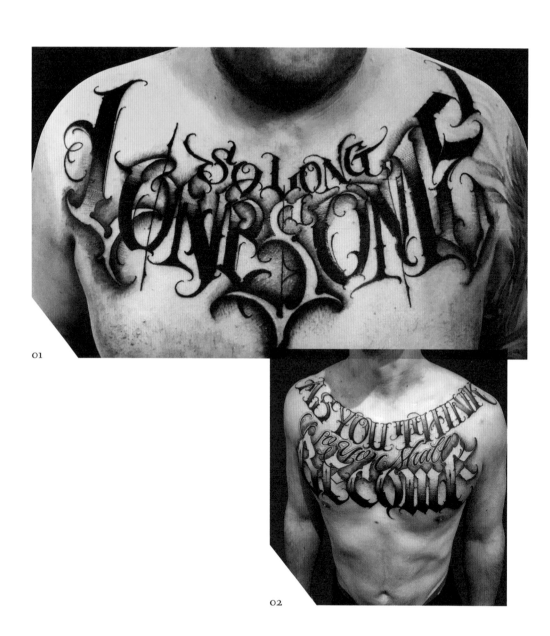

01

02

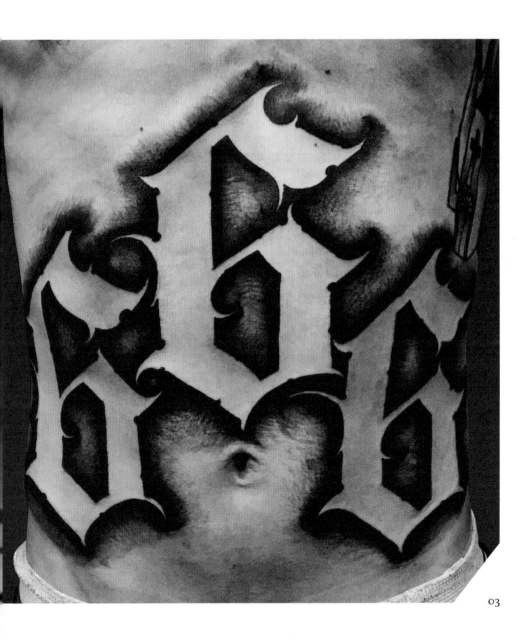

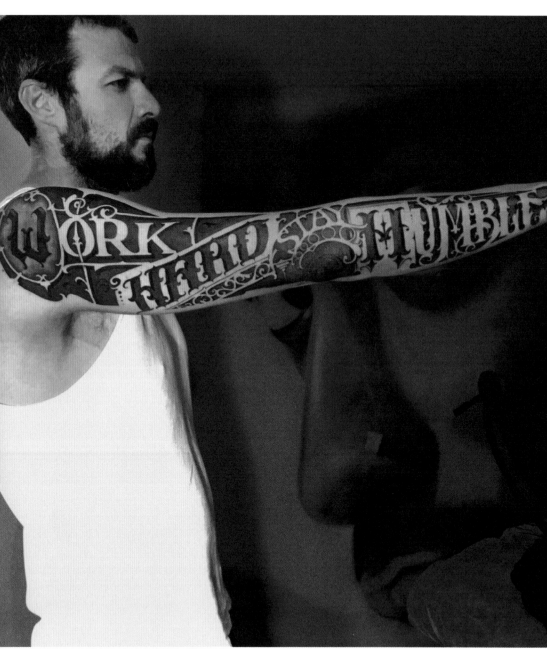

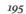

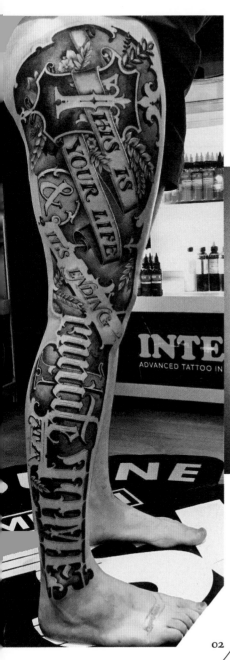

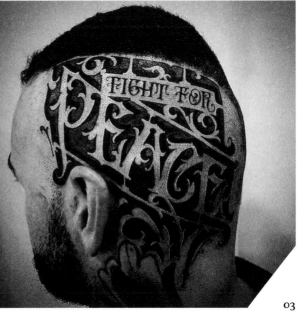

03

02

01 ~ **WORK HARD, STAY HUMBLE ~ S.T.**
02 ~ **THIS IS YOUR LIFE ~ S.T.**
03 ~ **FIGHT FOR PEACE ~ S.T.**

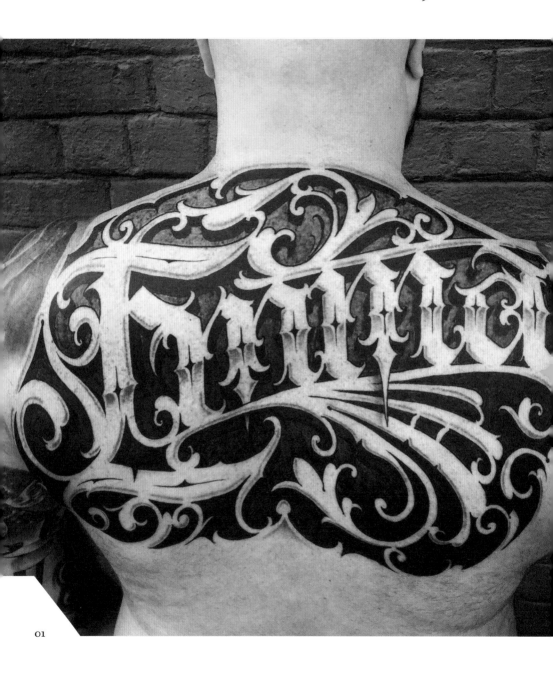

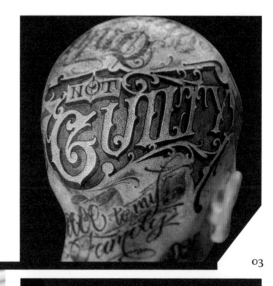

03

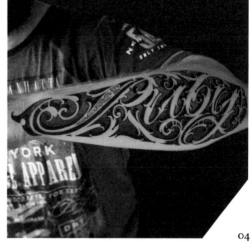

04

02

01 ~ EMMA ~ S.T.
02 ~ LAUGH WITH MANY, DON'T TRUST ANY ~ S.T.
03 ~ NOT GUILTY ~ S.T.
04 ~ RUBY ~ S.T.

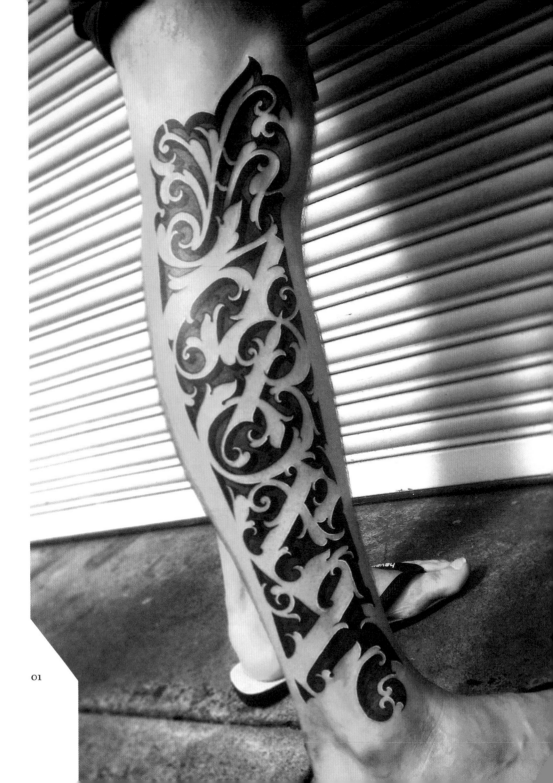

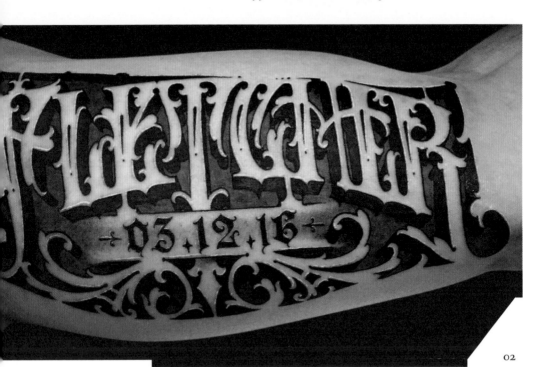

02

01 ~ ABEL ~ S.T.
02 ~ FLETCHER ~ S.T.

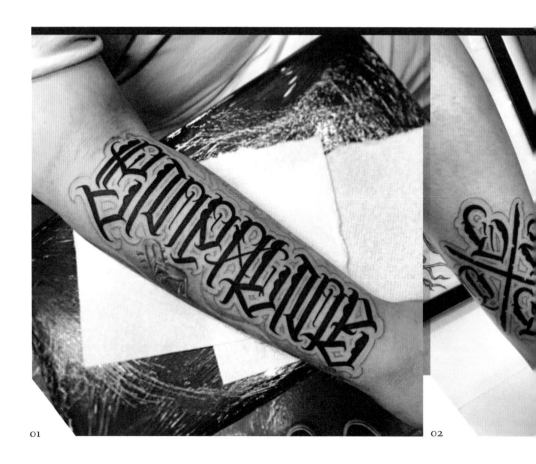

01

02

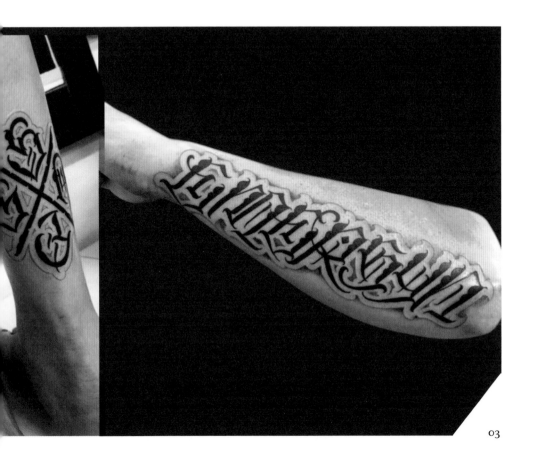

03

01 ~ **EMPALME ~ K.V.**
02 ~ **VARIOUS INITIALS ~ K.V.**
03 ~ **EMERSYN ~ K.V.**

02

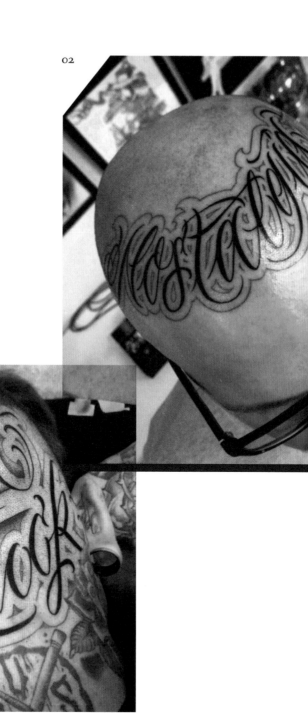

01

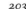

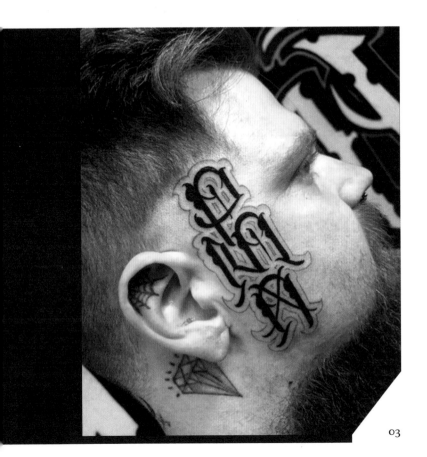

03

01 ~ **OUT OF LUCK ~ K.V.**
02 ~ **NOSTALGIA ~ K.V.**
03 ~ **PMA ~ K.V.**

01

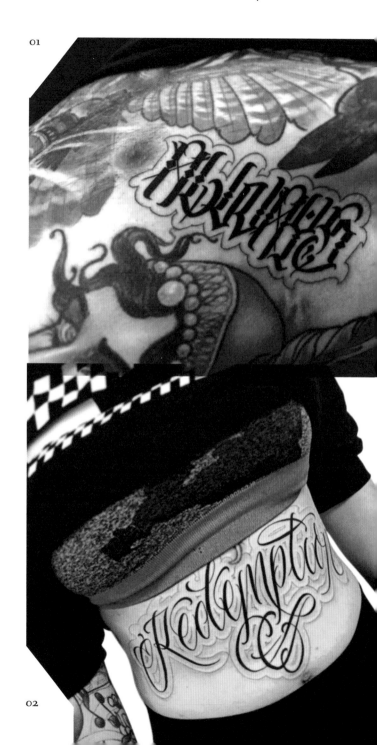

02

03

04

INTERVIEW

Before he became a tattooer, Kansas City-based Noah Moore worked as a freelance illustrator. Graffiti was his first foray into art, and he stumbled into his tattoo apprenticeship, with Tony LaRose of Stigmata Tattoo, as a trade for a mural on the side of LaRose's shop.

More than a decade later, Moore is known for a lettering style that merges classic sign painting, graffiti, and illustrative and three-dimensional forms. It's got flavours of the old but is wholly fresh, and that's the thing … the lack of pure definition puts Moore's lettering in the New School vanguard.

01

BB ~ Tell me a little about yourself, if you would be so kind.

NM ~ My name is Noah Moore, and the name of my shop is Old Souls Tattoo in Kansas City, Missouri.

BB ~ How long have you been tattooing?

NM ~ This year would mark fifteen years.

BB ~ What other shops did you work at prior to opening Old Souls?

NM ~ I owned a shop that was part of a franchise, called Freaks Tattoo, which had three locations, and which had quite a few

02

names in the industry come through. I worked for that guy for about a year and he was telling me he was considering closing the fourth location because he was spread a bit too thin, and I jokingly said that I would buy it. He ended up offering it to the guy who taught me how to tattoo, Tony LaRose. Tony said he would do it, but only if I partnered up with him.

BB ~ That's cool, that he thought that much of you to want to partner with you.

NM ~ The owner of Freaks thought I was too young and a little too wild, so he was a bit hesitant. Hell, I had my bags packed and was ready to move to New York City at the time.

BB ~ So did you have a pretty solid, traditional apprenticeship?

NM ~ The guy that apprenticed me owned a shop called Stigmata Tattoo. I stuck around there for a year and a half or so, and did some

01 ~ DTC ~ N.M.
02 ~ H ~ N.M.

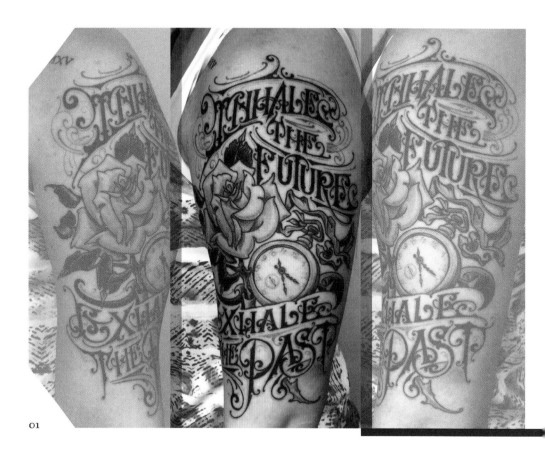

01

tattoos there. I came from a real illustrative background and did a lot of illustrations for magazines, plus my graffiti, so I was pretty much always self-employed.

BB ~ Was graffiti what got you interested in tattooing?

NM ~ Tattooing was always on my mind because it was rebellious and I was a graffiti writer/little shithead. I painted this mural

on the side of this tattoo shop called The Lion's Den and we ended up coming up with a deal: the owner said he would apprentice me and pay me half of what it was for the mural, and use the other half for the apprenticeship. That place didn't even last a full lease term, but I did my first tattoo there on the owner.

BB ~ So how did you end up with a new apprenticeship with Tony?

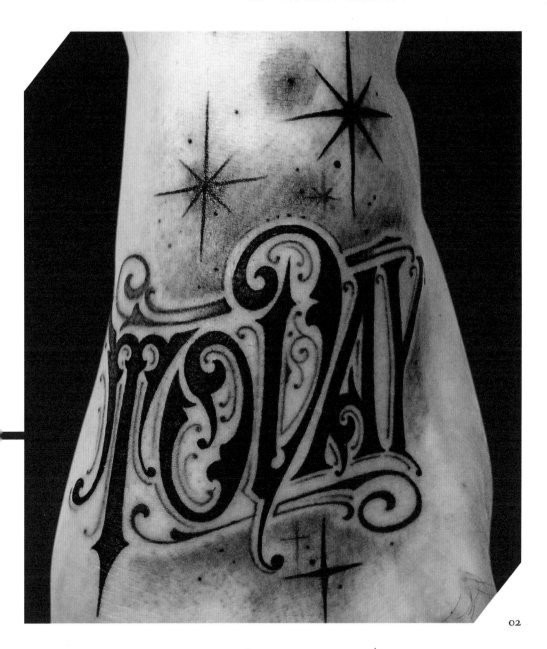

01 ~ INHALE THE FUTURE, EXHALE THE PAST ~ N.M.
02 ~ TODAY ~ N.M.

NM ~ One of my friends had me draw up a tattoo for him and wanted me to go in with him when he got tattooed, which was at Stigmata. Tony saw the drawing and asked who did it, and my buddy said, 'this guy right here did!' He was kind of blown away and said that I should be tattooing. I broke down the story for him, and he said he would give me an apprenticeship.

BB ~ How long did your apprenticeship last that time?

NM ~ About a year, and then he decided to go on the road and start selling body jewelry. I opened up a little studio that was in a head shop and thought I could manage that. I did that for a little while and the owner of Freaks Tattoo recruited me to come work at his place. I was fortunate to work with some very great artists and we all really developed a lot in that year or so.

BB ~ It's the best environment, where you can feed off each other. So what was the next step?

NM ~ I took the deal to buy into Freaks. I'd just turned twenty-three years old, in August of 2003, and on September 1st, I signed a lease on the building. I owned that thing for a good nine or ten years, and really, it was all mine. I paid for the franchise of the name, but after a while, I began thinking that the name was stupid. The location I was in, I was kind of confined to, but had I moved in to a different part of town where the competition was, I would have been his direct competition with the same name.

I decided to cut my ties and completely rehab a building, change the name and just start over, and opened Old Souls in 2012.

BB ~ Were you always interested in lettering?

NM ~ I was always into signage, and I've always been into lowriders too. I kind of grew up in the hood, so there was a lot of gang graffiti, a lot of cool cars that had cool, curly pin stripes and lettering and stuff like that, and I was super into it. So, I always tried to emulate that stuff with little doodles on paper in school, and lettering just became the thing. From there, it was just trying to develop my own style, and rub elbows with graffiti writers, and eventually I kind of made a small name for myself.

BB ~ Who were some of the guys that were big inspirations to you at that point?

NM ~ Being involved with cars, and doing illustration work for publications, doing mural jobs, but I wasn't schooled in the way that maybe I should've been, or maybe I didn't respect tattooing in the way I know now that I should've done, but for a long time, I was the guy that other people were trying to feed off. I mean, I owned my shop when I was pretty young, and I had to get employees, so employees ended up being not as good as I was, so they always fed off my work. Honestly, I felt like I was always giving and never really receiving. I was staying so busy thinking that my shit didn't stink. My good buddy Jimmy Little, who I taught how to tattoo, told me,

01

'man, if you could just focus on tattooing and not all the other shit, you'd be a really good tattooer!' and I just thought, man, I can't turn my back on all these things. I actually have a tattoo of a Ferris wheel on my kneecap, kind of signifying all my hobbies coming and going. It wasn't until I decided to take tattooing real serious – and as embarrassing as it is to say, that was in 2011. I decided I was going to move into the thick of the competition in my city, and decided I was going to try and stomp everybody's ass.

02

01 ~ CAN'T STOP ~ N.M.
02 ~ TI KCUF ~ N.M.

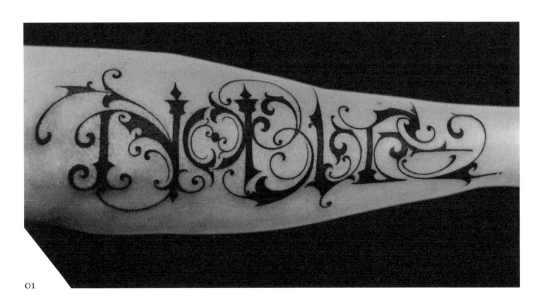

01

BB ~ Damn, so just a few years ago you started taking it seriously?

NM ~ Yeah man, really, 2012 is kind of the start of my career. That's when I was like, fuck everything else, I promised myself I wouldn't do anything besides tattooing.

BB ~ That's crazy, Noah. Did you even do a lot of lettering in the other shops prior to Old Souls?

NM ~ You know what man, for the longest time, I never really crossed the two paths of my signage background and my graffiti background. I learned in a couple years of doing a lot of graffiti that it just belongs on walls, it doesn't belong on skin, so I did script, like everybody did. I did that for years and years and I thought, 'how can I make this a little fancier?' And I'm sure everybody kind of thought the same thing, because script

remains script. One day, I said okay. Some girl came in and wanted her name, Brianna, and I was so bored of writing in loops that I decided to do something different, and I showed it to her and she totally went for it! It had a domino effect, and I did another one and another one. I guess it has brought something different than what people are normally seeing, which is nice. It was just single stroke lines; real simple, classier letters, and it's become thicker and 3D and drop shadows, and now I feel like I need to bust out with a little more!

BB ~ There are so many people that keep pushing along and really never take a good look at where they are, or even consider if they should make any changes to not only their tattooing, but maybe something like changing their approach to a tattoo. That's why my favourite tattooers are ones who kill it in every area of tattooing.

NM ~ Right, so to go back to your earlier question about inspirations: Grime is definitely a guy who has laid a lot of influence on a lot of tattooers. Filip Leu, that guy is the godfather, to me, of tattooing. I wanted everything he has ever done on my body, and I wish I could replace everything I've got with a Filip Leu body suit!

BB ~ What changes have you noticed over the course of your career?

NM ~ The biggest thing that I've noticed, and again, I haven't applied a serious focus

on lettering until the past few years, and also so many people do lettering because it's a requirement, people walk through the door and they want 'Charlie' on their neck. People that don't have a creative background or even the hunger to be good at lettering, they just start to add more swirls, or more bullshit. That seems to be more of a standard now. It's like, how many more underlines can you add to that thing? People are still confined to their box.

In the past three years of me taking it seriously, I started watching tattoo-related videos and reading tattoo magazines' interviews a little more. What really stuck with me is the question: 'How are you giving back to tattooing?' I don't want to sit here and suck the teat until it's dry. I want to be able to give back too, and trying to figure that out is a tough thing to do.

BB ~ Do you usually draw directly on the skin, or if you have some time, do you like to have a few sketches done?

NM ~ The past few conventions I've done, I've drawn everything right on the skin, and I get kind of into the mood of doing that. I think there's something beautiful about that. Sometimes it's hard for me to spit things out rapidly because I really want to scrutinize it to death, but at the same time, I think that's where the beauty kind of falls into it. You can draw it on paper all you want, but when you lay it on the body, it won't have the same harmony as it would if you were to draw it directly on.

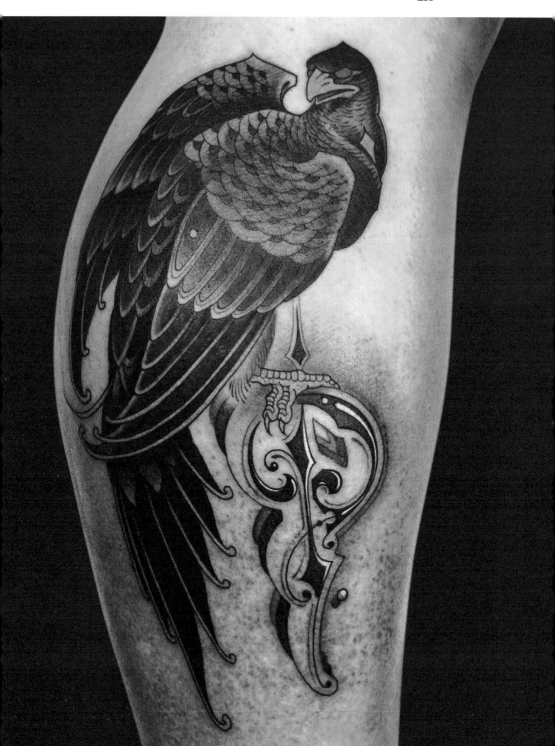

If it gets down to a specific name with some dates, and it's for a certain area, I'll probably sketch a little on paper first to give them an idea, because some people want to see it first.

BB ~ Do you think that you've been able to transfer the way you approach, say, a larger graffiti mural, to a large tattoo on the body? Any similarities?

NM ~ Two totally different beasts. I never do a sketch when I go paint, which I always get a bunch of shit for but also get praised for. If I got out with a crew of guys and we're going to do a big mural, I always want it to be a gift that's kind of unwrapping itself, you know? Plus if you go with a sketch, you're always struggling to make it look like the sketch. Whereas, with no sketch, it's perfectly fine. If I have a sketch, I don't even need to be here, you can do it for me.

BB ~ Where do you see tattooing headed in the future?

NM ~ I think with all of the instant access and instant gratification, it's going to be a nice revival. I've been pulling back from the social networking. I think a lot of people are taking from the same source and it's starting to look the same. It's just one harmonized song. I think there's going to be a crash. I hope it happens, because when people are put into a tight situation, they react in ways that they never thought that they could. I don't want my stuff to look like anybody else's shit. I think a lot

of people are going to start taking from other valuable sources. If you want to do a tattoo of a rose, look at a real rose. I don't want to say that I'm bringing anything new to the world because there's always signage stuff, but I definitely feel like I kind of broke a few eggs to make an omelette, and tried to do something a little different with lettering, but I'm just pulling from somewhere else, you know? The old greats from London, signage in the early 1800s, that's where my influence comes from.

If somebody's nose gets ahead of yours in the race, at least you're going to catch the scent, which might change your total operation. If you're constantly ahead of the game, what are you going to learn? It's hard to find influence when you don't have peers. As much as I've been successful, I also have to live up to my own standards, and that's stressful!

INTRODUCTION

The evolution of tattoo lettering styles stems from advancement in and expansion of the medium. The simple trajectory charted in this book sees growth from traditional to script, and from West Coast to New School. There is clarity in how broadened visual culture reference points and constituent client communities (as well as practitioner backgrounds) drive this natural progress. Nothing within it is particularly earth-shattering in the context of tattoo history. Yet there are outliers.

Among these is the emergence of the dynamic and arresting calligraphic lettering style.

The calligraphic style is notable for its fluidity and its rhythm. While other lettering styles featured in this book balance attitude and legibility, the calligraphic style is predicated on delivering tone in the shape of pattern. Letters themselves become less important than the overall composition – the opportunity is to turn phrase into a graphic vehicle imbued with personal meaning.

Work by Portuguese artist Gordo Letters, American Joseph Ari Aloi (JK5) and New Zealand-born Mayonaize (who is interviewed by B.J. Betts in the following pages) is indicative of the glorious potential of the calligraphic style. Each of the three comes from the same turn-of-the-century milieu that produced New School forms (in fact, each is also adept in a number of lettering systems), and the calligraphic represents the furthest push to date from the conventional thinking of letterform.

Because of this, the calligraphic style exudes strength. It can also be graceful. It is always dependent on the compositional structure. Gordo, for example, produces flowing, almost brushstroke-like forms. By contrast, Aloi, a graduate of New York's Pratt Institute, creates sweeping, heavily textured patterns from a series of tighter lines. With his arabesque flourish, Mayonaize is able to manipulate words to fit circular and flat space with equal aplomb. For each, the decorative quality of the output is undeniable, and their respective articulations are equally at home on canvas, on skin and even – in the case of Aloi, who has collaborated with fashion label Comme des Garçons – on textiles.

A calligraphic style of one's own might be tough to master, but the style allows for myriad opportunities in confronting a spectrum of design challenges.

01 ~ CALLIGRAPHIC TEXT IN AN ORIGINAL
ARTWORK BY MAYONAIZE

HOW TO GUIDE

At its extreme, combined letters in the style produce arresting but almost illegible patterns – don't worry, it's part of the allure. Everything begins with simple forms, recognizable for their chiselled edges that mimic strong brushstrokes. Master the basics of line work here and you can push limits unimaginable in other styles.

- With the calligraphic style, using a chisel-tip brush will give you the desired effect. You should become familiar with pen types that will give you different serifs and letter shapes.

(Yes)

- Different brushes will give the font a completely different look and feel. Also, using varying pressure will give you that thick/thin contrast.

(Oh Yeah)

- Adding extra embellishments to the letters always helps, but as with any other style, don't overdo it. A little goes a long way. This font relies heavily on the curves to break up the heavy vertical make-up of this style of lettering.

(Levels)

- Use what's available and allow the font to do some of the work for you. As seen here, extending the t down into the connector of the e brings it all together nicely.

(Cents)

ABCDEF
GHIJKL
MNOPQ
RSTUV
WXYZ

- With this capital alphabet, keep aware of the open space and use that to emphasize the letter shape to help with legibility.

- This font is one of the more difficult to invent a new version of, so study as many versions as you can, and find one or develop one to your own needs or specific to the piece of art you're making.

England

Ruby Murray

Easy Dave

Calligraphic fonts used in
popular phrases and words.

*Calligraphic fonts used in
popular phrases and words.*

Galleon

Victorious

Courage

Marcus

Calligraphic fonts used in popular phrases and words.

Love

King of Kings

Hero

GALLERY

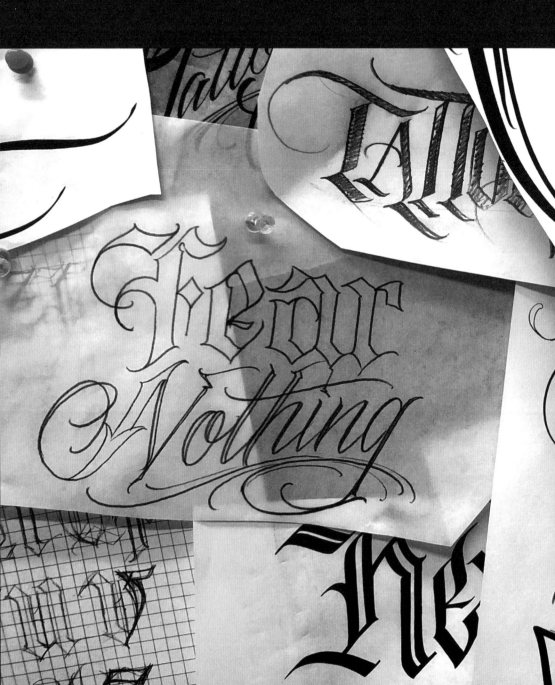

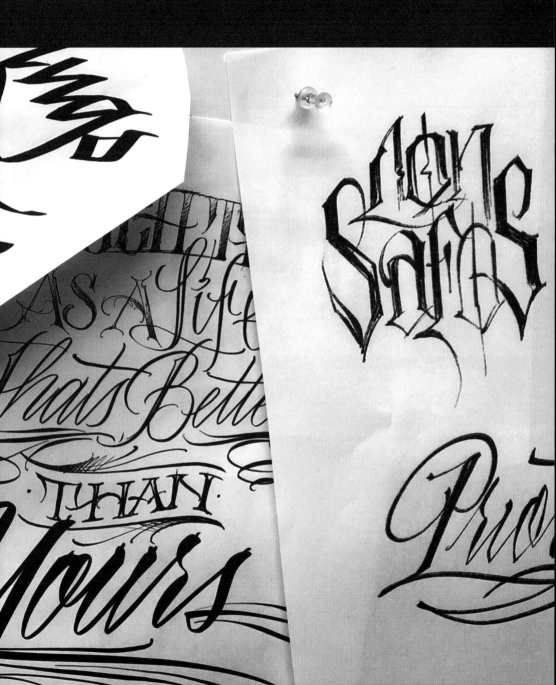

01

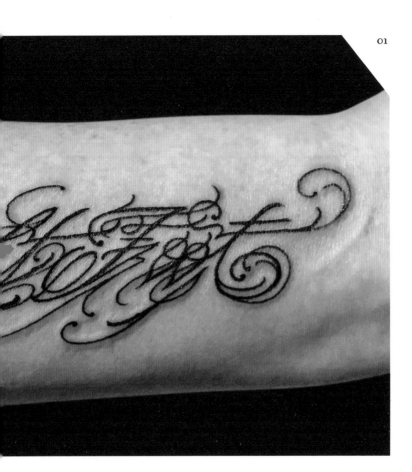

01 ~ **LEFT FOOT, RIGHT FOOT ~ J.A.**

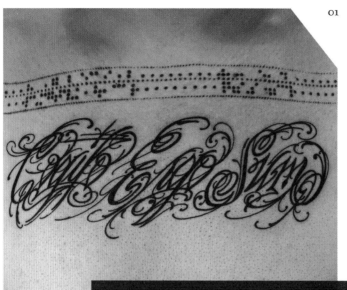

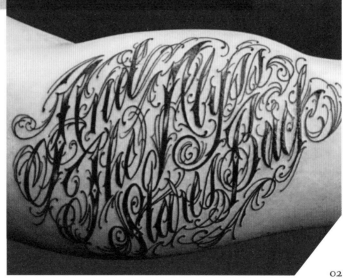

03

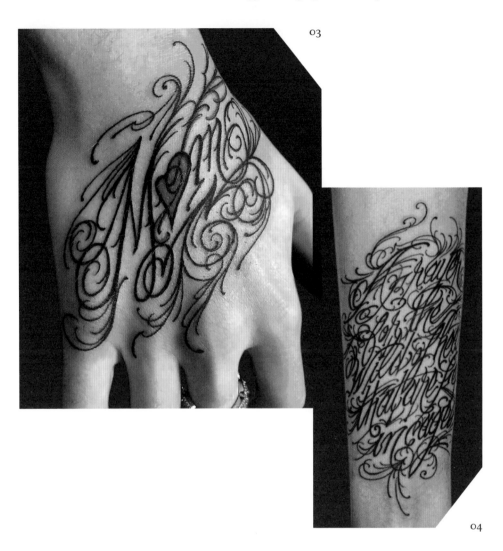

04

01

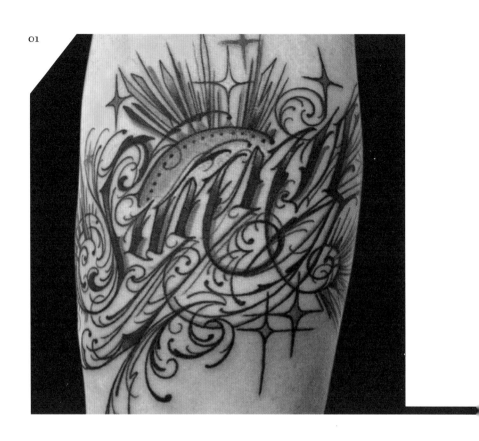

02

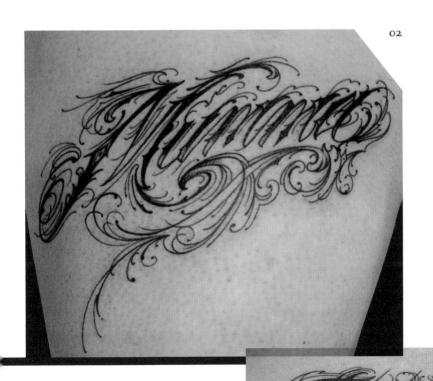

03

01 ~ SUNNY ~ J.A.
02 ~ MUMMA ~ J.A.
03 ~ DISCIPLINE ~ J.A.

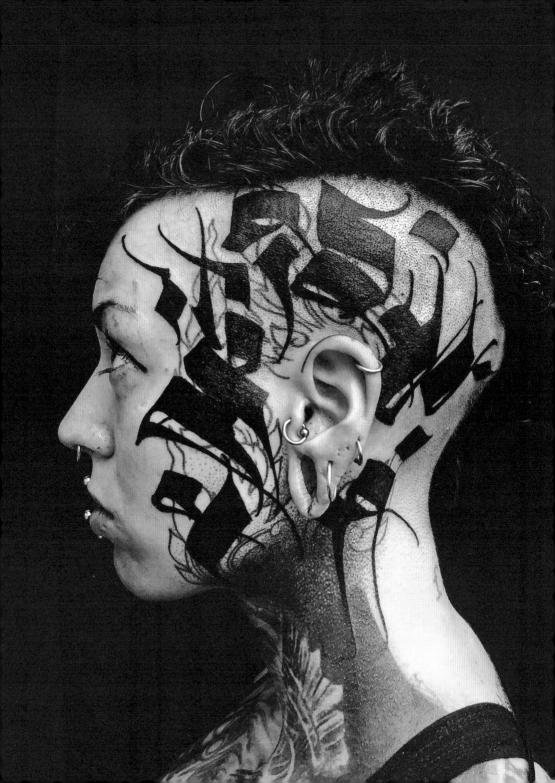

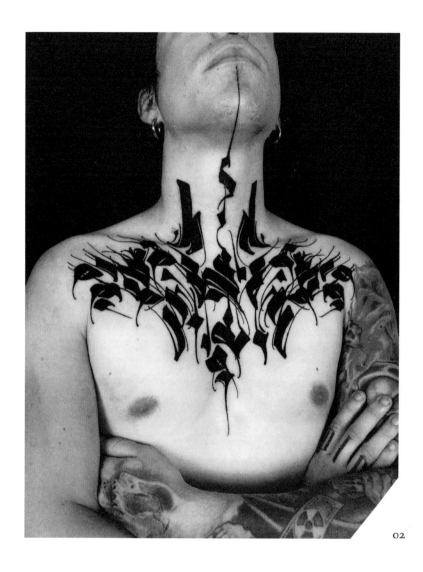

02

01 ~ ABSTRACT LETTERFORM TATTOO ~ G.
02 ~ ABSTRACT LETTERFORM TATTOO ~ G.

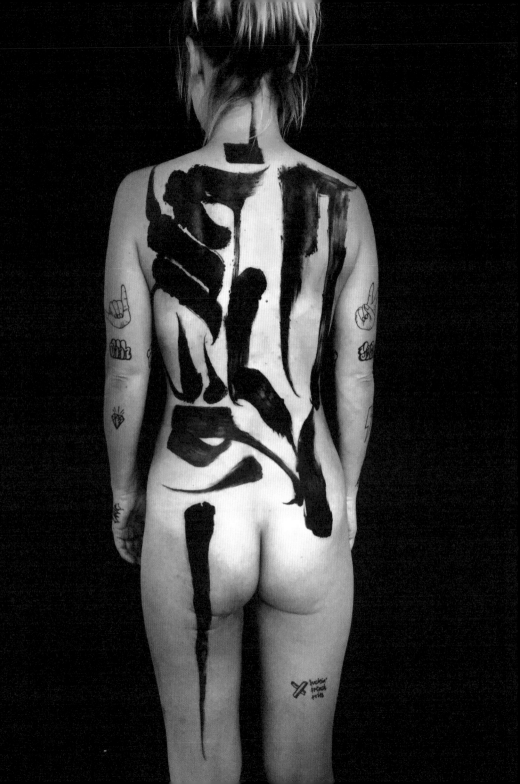

02

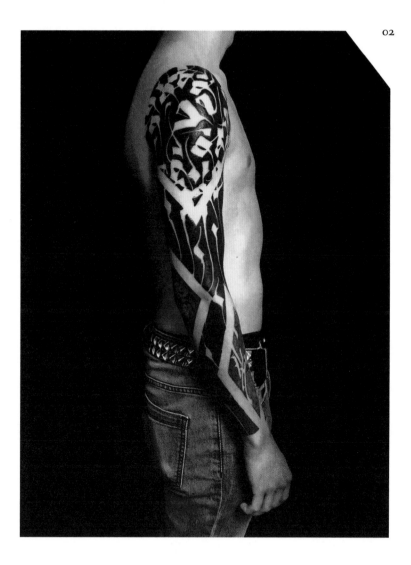

◁ 01

01 ~ OM ~ G.
02 ~ ABSTRACT LETTERFORM TATTOO ~ G.

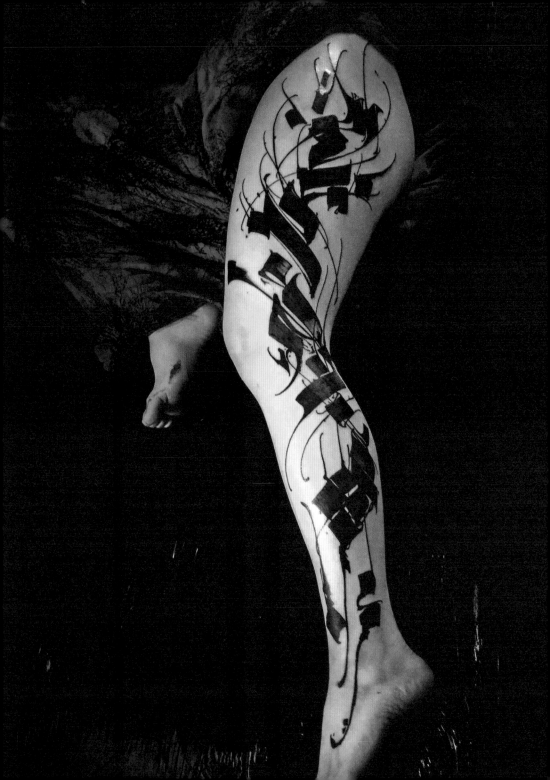

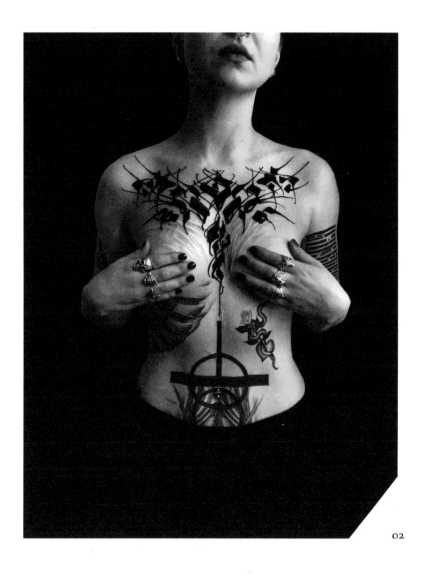

02

01 ~ **ABSTRACT LETTERFORM TATTOO ~ G.**
02 ~ **ABSTRACT LETTERFORM TATTOO ~ G.**

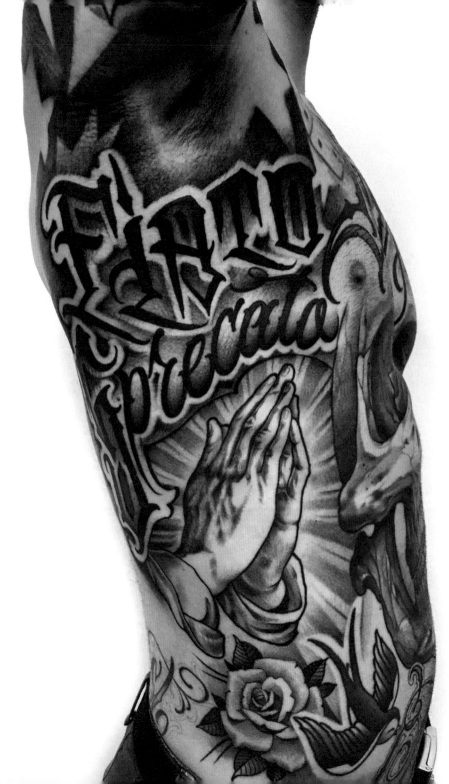

02

01

02

01

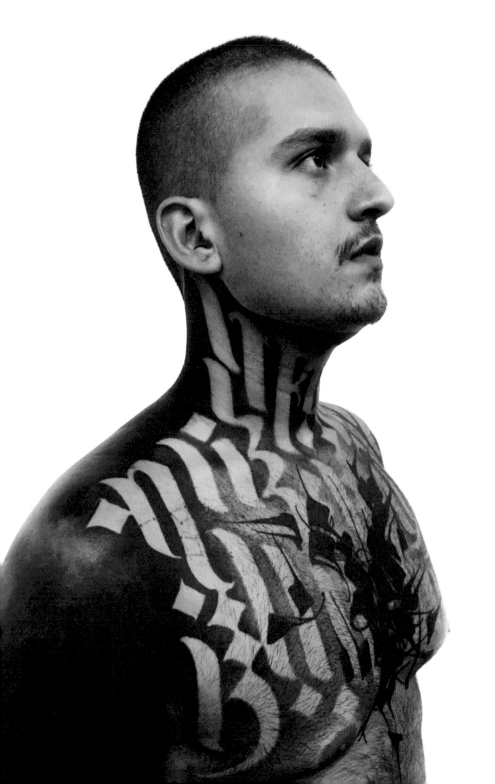

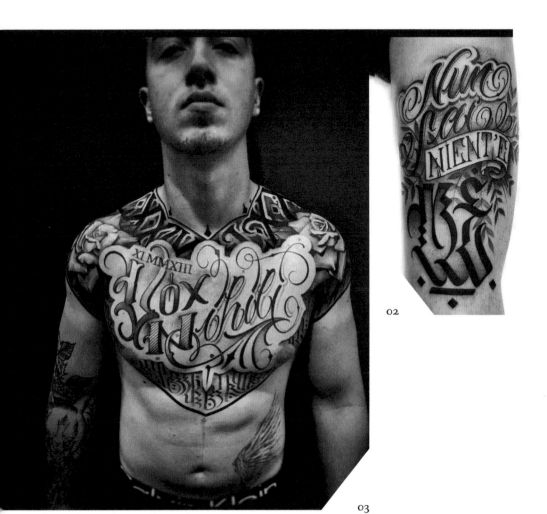

02

03

01 ~ COLLABORATIVE TATTOO BETWEEN G. AND D.V.
02 ~ NUN SAI NIENT'E ~ D.V.
03 ~ VOX NIHILI ~ D.V.

INTERVIEW

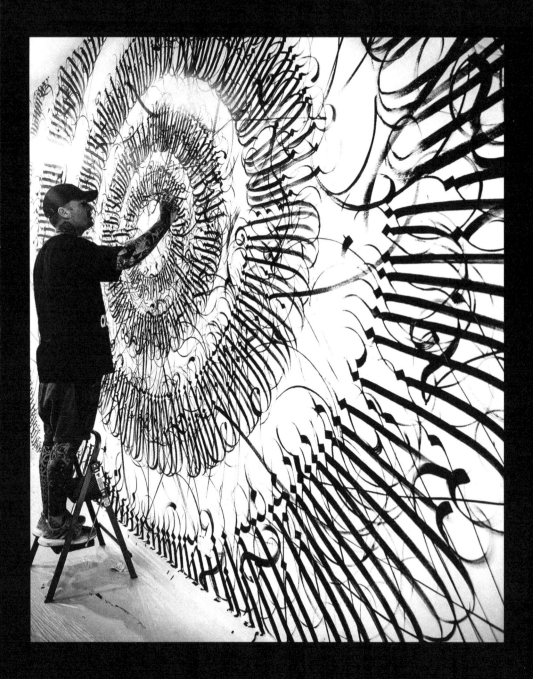

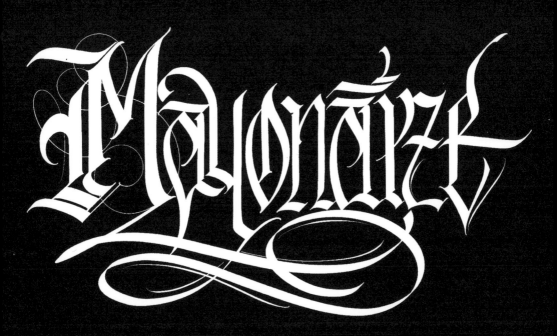

Born in October 1980, in Wellington, New Zealand, Mayonaize first gained artistic fame as a graffiti writer. Within the discipline, he developed a deliberate hand-style, predicated on complexity of form and precise execution. The influence, and importance, of street art on Mayonaize's overall output grew exponentially when he moved to Melbourne, Australia, in 2001. Within the city, he established a strong profile on the local scene and expanded his oeuvre to include fine art canvases, interior painting and, of course, tattooing.

Mayonaize started tattooing soon after his 2001 arrival in Melbourne, apprenticing at a shop in the suburb of Footscray. Benefiting from frequent lettering requests in the shops he's worked at, Mayonaize has transferred his unique calligraphy script style of lettering seamlessly from street art to tattooing. This forms a fluid and succinct body of work across all mediums and has made him a sought-after tattooer not only at his home shop, Oculus, but when travelling across the world.

BB ~ What role did art play in your childhood?
I've always had a relationship with art in some
capacity. I remember drawing robots when
I was very young, and as I got older I liked
to paint things that were more abstract and
expressionist.

M ~ Art didn't play a major role in my
childhood. I did enjoy drawing and painting
in high school though, and Art was the only
subject I passed – I scored a B minus.

BB ~ Where and when did you first discover
tattooing?

M ~ I discovered tattooing when some friends
of mine got a predator tattoo. At that time,
I started to draw tribal designs that the kids
at school liked. I would draw their favourite
ones onto their skin and mine as well.

BB ~ How did you get your start in tattooing?

M ~ I lied and told a shop owner (a guy named
Sharky), who was looking for an apprentice,
that I could already tattoo but I needed help
to get better. He had me bring someone in to
tattoo at the shop. He wanted to see if I was any
good. He gave me Huck Spaulding's *Tattooing
A to Z: A Guide to Successful Tattooing* and said
that when I'd read it I could start tattooing.
 I read it in two days and was then
put to work tattooing junkies for free, tracing
Cherry Creek flash sheets and making needles
in the time between tattoos.

BB ~ What styles were you initially drawn
to when you got into tattooing properly?

M ~ I was drawn to biomechanical stuff
and the likes of H.R. Giger, Aaron Cain and
Guy Aitichson.

BB ~ When did you get into lettering then?
What was the initial appeal? How did you learn
the 'rules' – line weight, spacing, and so on?

M ~ I was always the 'lettering guy' at the
shops I worked in. I enjoyed drawing and
tattooing lettering. I like to create flow and
to make clean tattoos. I also like the look of
lettering tattoos – so the appeal was aesthetic.
I guess I learned the 'rules' from working in
street shops as I did a lot of script. Travelling
also helped as I was able to pick up tips from
other artists along the way.

BB ~ When did you first develop the
calligraphic style you are known for?

M ~ When I started doing graffiti. I had
terrible tags and as I became a writer I realized
I needed a hand-style. So I got obsessed with
tagging! Once my tags got better people saw
them and asked me to tattoo them on their
skin. This was the first step in developing
my style of lettering

BB ~ How do you describe that style?

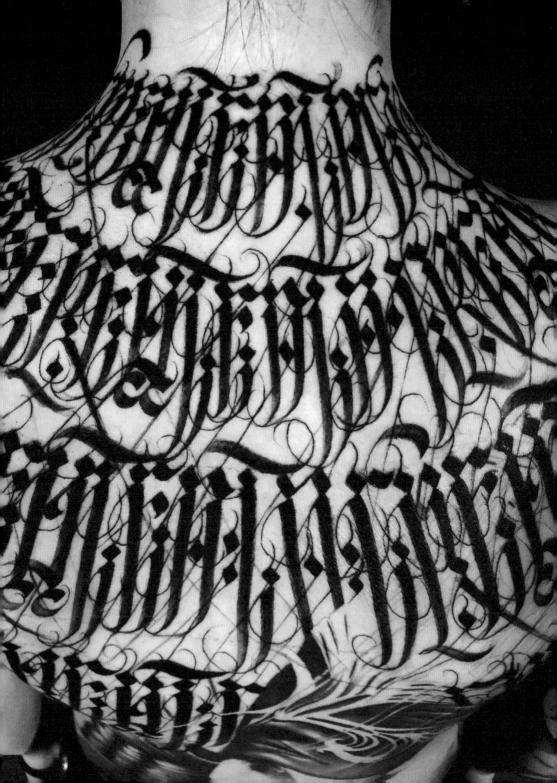

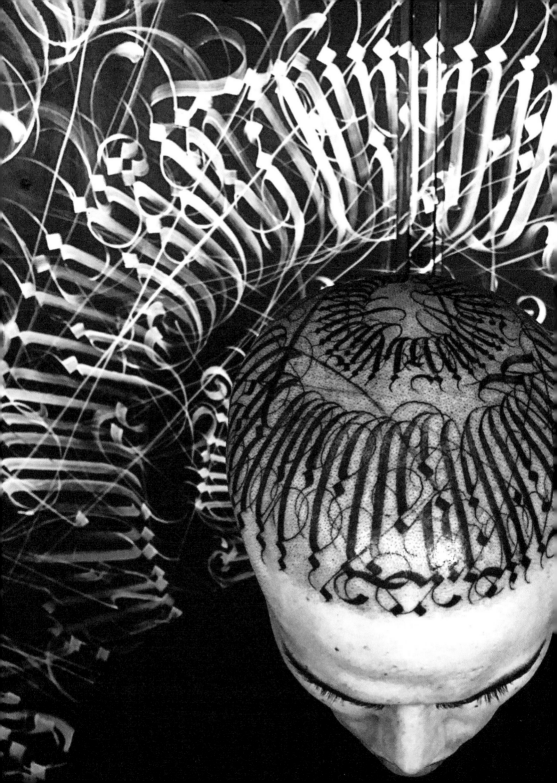

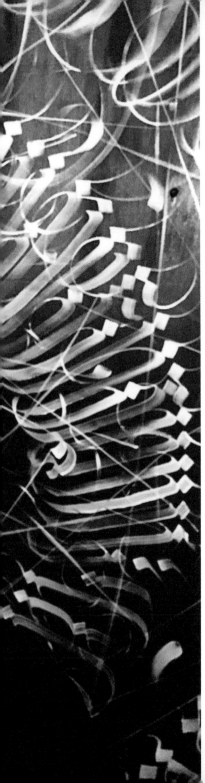

M ~ Random and controlled motor-functional movements in the shape of letters to create an aesthetically pleasing design or pattern.

BB ~ What are some fundamental components of it aesthetically?

M ~ Rhythm and flow, controlled chaos and random movements that are enjoyable to do.

BB ~ What considerations do you make when applying it to the body?

M ~ I like to follow the map the body provides. I want the tattoo to look natural, as if the owner grew into it.

BB ~ Do you use stencils or is the lettering placed directly on the skin?

M ~ I don't stencil. I draw onto the skin with markers first.

BB ~ What are the fundamental rules of calligraphic style lettering?

M ~ Spacing and weight are most important. The letters are intended to create a symbol and are not to be read individually but to be seen as a pattern or design that provides meaning to the wearer. It is important not to compromise aesthetics to accommodate the letters. If it doesn't fit at first, try again. If the word or phrase has too many letters, don't change the spacing and size. Instead, find another way to fit them or a way to edit some out.

01 ~ ABSTRACT LETTERFORM TATTOO ~ M.

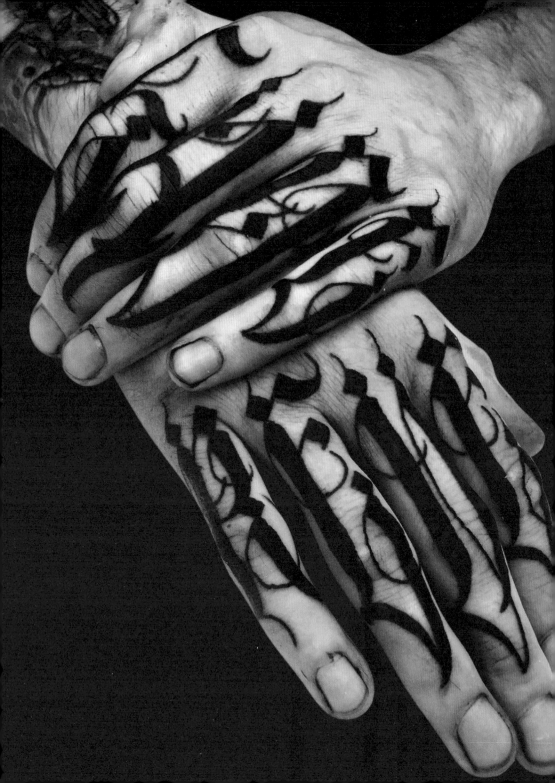

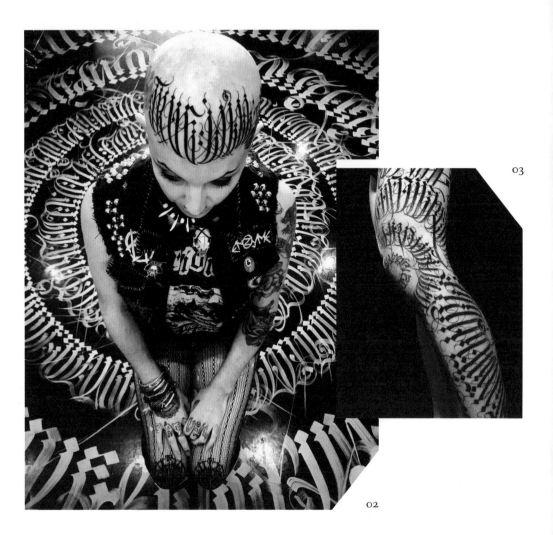

03

02

01

Never draw on paper, always draw freehand. Drawing on paper takes away the moment – calligraphy is a moment in time created on a surface; if it's created on paper it looks contrived. Always, always stay loose. Squint your eyes to see if you need to add more weight to some of the kicks so you can balance the piece. Make sure you follow the flow of the body.

Take your time. Of course, even when using letters to create patterns, always check your spelling!

01 ~ RENEGADE ~ M.
02 ~ TRUE WILL ~ M.
03 ~ ABSTRACT LETTERFORM TATTOO ~ M.

AFTERWORD

Jeff Carvalho

In middle school, I was into heavy metal and hardcore records, zines and graphic novels. Below the clock in my homeroom, my teacher put a sign that read: 'Time will pass, will you?' But instead of watching seconds turn to minutes, I dreamed of leaving class to go back to my room and bury my fourteen-year-old head into my burgeoning collection of metal ephemera.

I studied the graphics and lyrics religiously, learning every word, every beat, and drawing my favourite band logos from memory in notebooks. I'd leave my scribble take on word forms that signified the music that moved me: Van Halen, Metallica, JUDGE, Gorilla Biscuits, Operation Ivy, The Misfits and countless others.

This was a much more engaging curriculum than whatever my teachers planned anyway. To pass time, I zoned out in class and took to the white spaces in physics books to practise my craft, leaving my own form of graffiti in the hope of educating the next kids coming up to the music that empowered me and my friends. Sure – the superintendent might have called it 'defacement', but I thought of it as a way to make them better.

I recall the first time I saw Texas thrash band DRI's logo scribbled on an upper classman's white marble notebook. DRI was a band a full generation before my time. I'd never heard their music, but their logo, with

its skank-dancing man, told me everything I needed to know about the band and their music. The appropriation of road signs and school crossing iconography seemed especially pertinent to a teenage student.

Zine culture changed it all for me. *Factsheet Five* was aggregating the very best zines in the world and for a couple of bucks – or sometimes just an S.A.S.E. (self-addressed stamped envelope) – the world of hand design was available through my physical mailbox.

Maximum Rocknroll opened the floodgates to the music and graphics of the hardcore and punk scenes – and the magazine has remained alive and kicking since 1982. Self-expression came through the jacket art on 7-inch records and cassettes. Graphic inspiration came from the overworked jackets, meticulously drawn and quartered for a consumer like me, leaving me hungry for more. With limited access to desktop publishing tools of the time, young artists designed their own wordmarks and lettering. The advertisements in *MRR* were even stronger examples: release listings were hand-lettered and typeset. Labels were important as an inspiration in hand lettering as well: Dischord and Touch & Go, two titans of the moment, had wordmarks certainly done by hand.

And sitting at that school desk, I loved nothing more than to mimic them, writing the names and marks over and over again until

A selection of original hardcore band flyers that show expressive hand-drawn lettering.

I myself could quickly draw them. The best part is that through it all, through all the mundane classes and fractured attempts at drawing Suicidal Tendencies in perfect letterform, I passed middle school. But it's very clear what lessons I chose to take with me.

Years later, the powerful draw of the logos and hand-types I was enamoured with as a youth remains. When I first got involved with streetwear, first as a fan and later for my career, those same fonts were part and parcel of the vernacular. Through it, I also became familiar with the likes of B.J. Betts, Mister Cartoon and JK5, finding, through fashion, an intersection of all my passions, linked, of course, by a mastery of lettering.

Thank you to Raymond Pettibon, Jeff Nelson, Robert Crumb, James Hatfield, and the countless unnamed artists of the zine and metal/hardcore/punk age who expressed their work through hand lettering. Their influence is as indelible as ink. Celebrating the work of hand letterers – be it on paper, record covers or skin – is an important statement in honouring each individual's technique and form. And while their work would later be led by digital tools, the truth remains: a free man or woman with a free hand will change the world.

A selection of original hardcore record covers that show expressive hand-drawn lettering.

BIOS

B.J. Betts

Chris Law

Nick Schonberger

B.J. BETTS – Born and raised in Delaware, B.J. combines more than two decades' experience in the tattoo industry with firm training in traditional graphic arts. B.J. has led a revolution in tattoo lettering. His approach has inspired critical re-evaluation of hand-done typography among a new generation of graphic designers. Through both his tattooing and the publication of five industry standard guidebooks, starting in 2004, B.J.'s influence is widespread. In 2014, he collaborated with Intenze to create Formula 23, the world's first precision tattoo ink designed specifically for lettering.

B.J. lives in Wilmington, Delaware. He owns and operates Trademark Tattoo in his hometown and State Street Tattoo in nearby Kennett Square, Pennsylvania.

JEFF CARVALHO – Jeff has been covering streetwear and youth culture for over 17 years. He is the Managing Director of Highsnobiety and is the driving force behind the media brand's innovative platforms. He spends his downtime playing records and sharing his favourites with his kids.

ANDY CRUZ – The founder and creative nerve centre of House Industries, the design company known for their fonts and far-reaching collaborative work with Hermès, Jimmy Kimmel, Muji, Medicom Toy, House33 and The *New Yorker*. Andy's work is in the permanent collection of the Cooper Hewitt, Smithsonian Design Museum and the Henry Ford Museum of American Innovation.

CHRIS LAW – Chris comes from Bedford, UK. After studying graphic design and typography at London College of Printing, he and a few friends started the design agency U-Dox in London in 1999.

Crooked Tongues, a project of U-Dox, was one of the first sneaker websites that brought together like-minded individuals with a passion for sneaker culture and its surrounding elements. Through Crooked Tongues Chris met both B.J. and Nick, and they have been friends for almost the past two decades. Through their friendship and a shared passion for sneakers, tattoos and typography, this joint book project was bound to happen at some point.

Footwear design is his forte, but Chris designed this book as a passion project; his day job sees him in the role of Senior Design Director for adidas Originals in Portland, Oregon. Chris is also the co-author and designer of the book *Sneakers – The Ultimate Collectors' Guide* by Unorthodox Styles, published by Thames & Hudson.

NICK SCHONBERGER – A graduate of the Winterthur Program in American Material Culture at the University of Delaware, Nick has published his thinking about tattooing regularly since 2005.

His output has appeared in the popular press and in book form (most recently *TTT: Tattooing*), as well as via academic venues such as the annual Popular Culture Association conference. He splits his time between Philadelphia, Pennsylvania, and Portland, Oregon.

CONTRIBUTING ARTISTS

One thing we can't ever get back is time, and hand lettering definitely requires a good bit of it. With the current digital state we live in, the art of hand lettering is becoming less and less relevant. Nearly every stroke can be digitally replicated, almost immediately resized or revised in any capacity with just a few clicks, and printed with the same sharpness from millimetres to metres.

That's cool and all, but there's still NOTHING like seeing a perfectly hand-done note, name or monogram. Sorry, digital artists, but there's still something about seeing the handwritten words, looking through sketchbooks and watching artists draw on good ol' white paper that is beyond compare. It takes me back to times when I'd watch my grandparents write letters, fill out holiday cards and beautifully letter every other bit of correspondence with ease.

While social media plays a huge role in every industry these days, and you can literally see a tattoo that your friend just completed 5,500 miles away, it's also an endless realm of inspiration and reference for anybody in any trade. However, on the flipside of that coin, the amount of information can be overwhelming and overload your thought and design processes. While trying to keep the originality of your lettering intact, the other images you've scrolled by and saved on your phone or computer for 'reference' will slowly creep in. It's a double-edged sword, because we all want to see what's new and fresh but we don't want to rip off other artists who have worked to come up with that new letter or font.

The artists chosen for this book are among the best in the tattoo/graphic industry and are some of those who have paved the way for the other thousands of artists who have followed suit.

These artists take a tremendous amount of pride in keeping the art of hand lettering not only alive and well but also progressing, by constantly pushing the envelope. As with anything that requires some sort of muscle memory, dedication, repetition and understanding, the basics are integral ingredients for success. That recipe for solid lettering design will always beat the cheat code, and any other artist worth their weight will recognize when short cuts were taken. These artists didn't take that route. Instead, they've made sacrifices and spent countless hours drawing and redrawing until it was right.

Traditional

Steve Boltz
42 ~ 45

Eli Quinters
46 ~ 49

Dan Smith
50 ~ 53

Bert Krak
54 ~ 67

West Coast

Freddy Corbin
80 ~ 83

Kalm One
84 ~ 87

Orks
88 ~ 91

Jack Rudy
92 ~ 95

Big Sleeps
96 ~ 99

Vetoe
100 ~ 101

Mister Cartoon
102 ~ 117

Fancy Script

Brigante
132 ~ 135

Elvia Guadian
136 ~ 141

Huero
142 ~ 147

Henry Lewis
148 ~ 153

El Whyner
154 ~ 159

Vetoe
160 ~ 161

Em Scott
162 ~ 173

New School

Big Meas
188 ~ 193

Sam Taylor
194 ~ 199

Kaylie Vamp
200 ~ 205

Noah Moore
206 ~ 217

Calligraphic

Joseph Aloi
232 ~ 237

Gordo
238 ~ 243

Delia Vico
244~ 249

Mayonaize
250 ~ 257

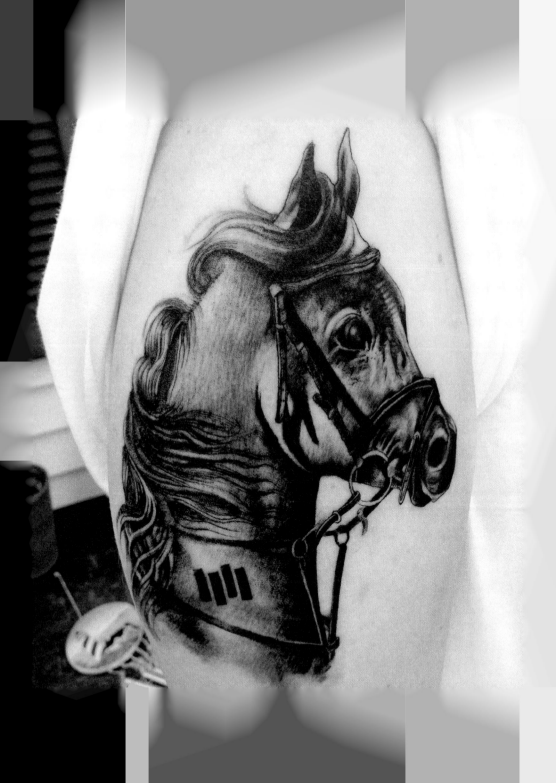

This book is dedicated to our friend
Gary Warnett.

B.J. BETTS – I'd like to thank Chris
and Nick for putting up with my sometimes
irrational thought process, and making sense
of this crazy hornet's nest I've always got going
on in my head. None of this would've happened
without either of you.
 I'd like to thank everyone who has
contributed to this book in any capacity, the
artists who took time out of their lives to send
me photos, and the people who have helped
shape the art of lettering into what it is today.
Thanks to every single one of my friends and
family for listening to me talk about this book
for years and pushing me forward to making
it happen. Love all you guys.

CHRIS LAW – Thanks to Andrew
at Thames & Hudson and his team for their
continued support, patience and guidance.
Thanks to Andy Cruz for a second set of eyes
and for the use of the House Industries fonts.
Last but not least, thanks to B.J. and Nick for
making my life a misery, nice one fellas, it's
been emotional.

NICK SCHONBERGER – First and
foremost, thank you, B.J. Over a decade of
mutual support for our respective creative
output has culminated in this wonderful
collaborative project. To Chris: without you
we'd have no structure – cheers for that.
I'd also like to thank Sarah, who reminds me
daily that it is a privilege to work with friends
and to put things out into the world.

Special thanks to Mark Borden, Shawn
Barber, Jeff Carvalho, Andy Cruz and
Russell Williamson.

GLOSSARY

BLACK AND GREY
A style of tattooing using only black ink and water. The ink is watered down to create softer shades of grey.

BLOCK LETTER
A plain capital letter.

COIL MACHINE
Uses an electromagnetic current passed through a pair of coils to move the needle in and out of the skin. This is the most common type of machine and produces the familiar buzzing that has become an aural standard in tattoo shops.

CURSIVE
A style of writing where words are joined together. In tattooing, cursive is most often applied as single stroke, linked lettering.

FINE LINE
A tattoo applied with a single or tight needle configuration.

FLASH
Pre-designed images that are generally found on the walls of tattoo shops.

FLOURISH
A decorative embellishment or stroke added to lettering, most common in West Coast and fancy script styles.

FONT
A distinct size, weight and style of a typeface. The word font original was used to designate the delivery, whether metal, wood, or today, a digital file, of the typeface design.

FREEHAND
When the design for a tattoo is drawn directly on skin rather than using a stencil application.

GLYPH
A character or symbol, such as a letter.

ILLUSTRATIVE
A style of tattooing that combines the different styles – American Traditional and realism. Typically, this is seen when the heavy outlines that define traditional are mixed with realistic shading.

MAHL STICK

A tool common in sign painting that supports the hand so that it does not streak or smudge the surface of the work.

NEEDLE BAR

Made of stainless steel with a small loop at one end and a group of needles (from one to many) soldered onto the other end.

NEGATIVE SPACE

The open skin that balances and creates legibility in the tattoo.

OLD ENGLISH

A bold block letter style based on Gothic script and calligraphy.

ORNAMENTAL

A style of tattooing that relies heavily on decorative shapes, body flow and geometry. Some calligraphic lettering tattoos may fall into this category.

PIKE

The Pike was an amusement zone in Long Beach, California, open from 1902 to 1979. Pivotal in the history of American Traditional tattooing, the area's great contribution to tattooing lettering comes in the form of the serif font that appears on page 33. Sometimes, a half-shaded traditional letter form is referred to as an Open Pike.

ROCKER

A lettering tattoo covering a distinct body part, i.e. the stomach or collar.

ROTARY MACHINE

These machines run on a small motor, which moves the needle in and out of the skin. One benefit is that these devices are very quiet.

SATURATION

A term used to describe the level of ink that is successfully absorbed in a healed tattoo.

SCRIPT

A more decorative version of cursive, with bolder vertical strokes.

SPACING

In tattoo vernacular, spacing
is the equivalent of kerning
– the adjustment of space
between letters that ensures
aesthetic clarity.

STENCIL

A guideline for a tattoo that
is transferred from paper to
skin. In the early 20th century,
commonly employed designs
were sometimes cut into
acetate stencils, an indication
of how frequently people
chose them. Today, stencils
are primarily single use.

STROKE

A singular line element that
forms part of a character,
straight or curved.

TUBE

Preferably made of stainless
steel (which needs to be
properly cleaned after each
use), tubes hold the needle
arms and needle bar in place.
Tubes also have a larger
grip attached. Today, many
tubes are fully disposable
for convenience and safety.

TYPEFACE

A set of one or more fonts
where each glyph shares
a clear, common design
feature. Fonts within
a typeface have specific
characteristics –
including weight.

WEIGHT

Refers to the thickness
of a letterform.

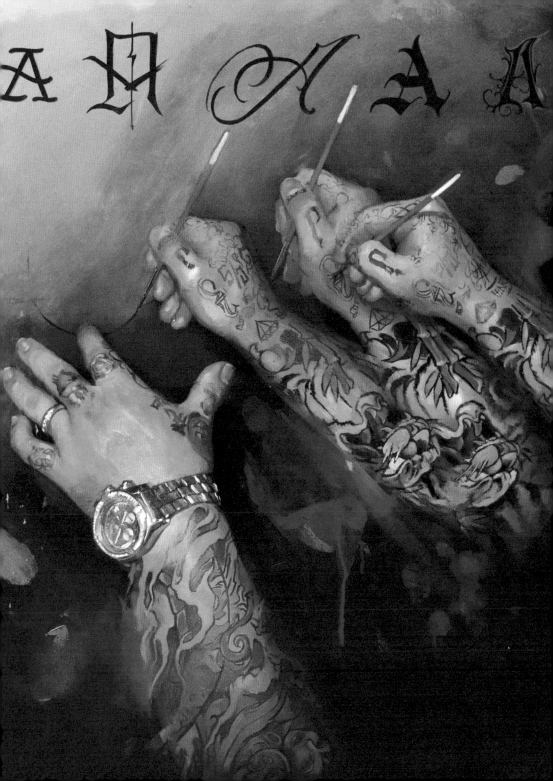

On the cover:
Front:
ARTWORK BY B.J. BETTS

Back (clockwise from left):
LIFE WASN'T MEANT TO BE EASY ~ BERT KRAK
ABSTRACT LETTERFORM TATTOO ~ MAYONAIZE
TODAY ~ NOAH MOORE
CALIFORNIA ~ EM SCOTT
HUNTER ~ MISTER CARTOON

The Graphic Art of Tattoo Lettering
© 2019 Thames & Hudson Ltd, London

Text © 2019 William Joseph Betts and Nicholas Schonberger

All Rights Reserved. No part of this publication may be
reproduced or transmitted in any form or by any means,
electronic or mechanical, including photocopy, recording or
any other information storage and retrieval system, without
prior permission in writing from the publisher.

First published in 2019 in the United States
of America by Thames & Hudson Inc.,
500 Fifth Avenue, New York, New York 10110

www.thamesandhudsonusa.com

Library of Congress Control Number 2019934304

ISBN 978-0-500-24153-0

Printed and bound in China by C&C Offset Printing Co. Ltd